George Auriol

George Auriol

ARMOND FIELDS

Catalogue Raisonné
by
MARIE LEROY–CREVECOEUR
Foreword by
PHILLIP DENNIS CATE

➔

GIBBS M. SMITH, INC.
PEREGRINE SMITH BOOKS

First edition.

Fields, Armond, 1930-
 George Auriol.

 Bibliography: p.
 Includes index.
 1. Auriol, George, 1863-1938. 2. Artists—France—
Biography. 3. Auriol, George, 1863-1938—Catalogs.
I. Leroy-Crevecoeur, Marie, 1947- . II. Title.
N6853.A84F5 1985 760'.092'4 [B] 85-2511
ISBN 0-87905-200-7

Designed by J. Scott Knudsen

Edited by Carole O. Cole

Cover illustration: *Scheherazade,* lithograph by
George Auriol, 1901.

All designs and ornamentation in the book are
reproductions of original artwork by George Auriol.

Printed and bound in Japan

TABLE OF CONTENTS

——

FOREWORD

7

PREFACE

11

BEAUVAIS

15

MONTMARTRE

21

CHAT NOIR

51

THE AURIOL STYLE AND ART NOUVEAU

59

PRODUCTIVE YEARS

71

THE BOOK BUSINESS

81

TYPOGRAPHY

91

JEAN-GEORGE

97

THE LAST TWENTY YEARS

109

CATALOGUE RAISONNÉ

123

BIBLIOGRAPHY

165

INDEX

169

FOREWORD

 was first introduced to the art of George Auriol ten years ago while involved in the organization of the exhibition and book *Japonisme: The Japanese Influence on French Art, 1854-1910*. His work made an important contribution to that project. Since then, Auriol's art has become much more widely appreciated and sought after.

Auriol type faces had so pervaded French typography of the first half of this century that "Auriol" became a generic term and knowledge of it was taken for granted. "Auriol," the typeface, has made the world lose sight of Auriol, the person and prolific artist. Yet, George Auriol was not only a significant designer of turn-of-the century typography, but an active participant in the Parisian avant-garde of the 1880s an 1990s. He, like T. A. Steinlen, Henri Rivière, and other young artists, associated himself early in the 1880s with the anti-establishment world of Rudolphe Salis's Chat Noir cabaret and journal. Auriol was, in fact, editor of the *Chat Noir* journal, and during the '80s played a literary and artistic role in the production of the cabaret and its journal. The Chat Noir and the environment of Montmartre brought him into contact with numerous writers, artists, collectors, and publishers for whom he designed monograms.

From the end of the 1880s throughout the artistically flourishing decade of the '90s, Auriol was a prominent contributor to the major print publications and exhibitions. In 1889 he joined Adolphe Willette and Paul Signac as an illustrator of programs for André Antoine's important and innovative Théâtre Libre. Over the next few years, others such as Rivière, Edouard Vuillard, Henri Ibels, Louis Anquetin, and Henri de Toulouse-Lautrec were added to this list of youthful contributors to the designs of the Théâtre Libre programs. Auriol's color lithographic floral design reveals his strong affinity with Japanese aesthetics as do his earlier stencil-colored projects for the Chat Noir shadow theatre programs

and his Japanese-inspired monograms for Rivière and himself. As such they place him in the forefront of the Japonisme movement at the end of the century. By absorbing Japanese sensibilities he expanded greatly upon Western concepts of design and color and, indeed, defined with his art essential aspects of what was to become the "Art Nouveau" aesthetics.

Bois Frissonnants, his color lithographic contribution to Andrè Marty's influential print publication *L'Estampe originale* of 1893, visually interprets with subtle nuances of secondary and tertiary colors Charles Cros's symbolist poetry. That same year he created in the medium of woodcut the head piece for the introductory page of *L'Estampe originale* and also exhibited at Durand-Ruel's gallery with the prestigious Société des peintres-graveurs. Although lithography was invented in 1798, Paris unwittingly celebrated the centennial of the medium with an exhibition in 1895; Auriol was among the young contemporaries included. In 1896 and 1897 the print impressario Ambroise Vollard, selected Auriol to participate in his two important publications *L'Album des peintres-graveurs* and *L'Album d'estampes originales de la Galerie Vollard.* Although Auriol's art was highly appreciated and utilized among literary, artistic, and bibliophilic circles, his collaboration with the Larousse Encyclopedia and the sheet music publisher, Enoch, was to greatly accelerate and enhance public recognition of his art and typographical designs.

Auriol entered the twentieth century as the quintessential French designer of book illustrations and typography. He, like other recently reappraised artists of the end of the nineteenth century such as Henri Rivière, Eugène Grasset, and T. A. Steinlen, emerges as an influential component to the rich and varied artistic period known as the "Belle Epoque." Knowledge of Auriol and his art is, indeed, essential to a full understanding of Art Nouveau aesthetics and the artistic community of the period.

Armond Fields's unique enthusiasm for turn-of-the-century French graphics has motivated him to amass a large collection of Auriol's art. As with his recent book on Henri Rivière, Fields's strong desire to understand the psychology and life of artists whose works he greatly admires, has led to this sensitive and revealing biography of George Auriol.

Thanks to the collaborative research with his Parisian colleague, Marie Leroy-Crevecoeur, the book also serves as the much needed catalogue raisonné of Auriol's printed works.

Indeed, Armond Fields's systematic approach to collecting, researching, and documenting the life work of artists, such as Auriol, who were active and much respected during their own times but not well known today, contributes greatly to the field of art history as well as to our own intellectual and visual enrichment.

PHILLIP DENNIS CATE
Director
Jane Voorhees Zimmerli
Art Museum

PREFACE

"ENEROUS, happy, contradictory, childlike, partial, paradoxical, proud, faithful, devoted." So wrote Auriol's son, Jean-George, just after his father had died. To Jean-George, his father was a caring, concerned, and committed person.

To each of his friends and colleagues, Auriol was a unique individual. Henri Rivière, Auriol's first friend and coworker at the Chat Noir cabaret, enjoyed his enthusiasm, his beliefs, and his outpouring of creativity. Maurice Donnay, a well-known writer, perceived Auriol as one of the most original literary people he had known. To Yvette Guilbert (of Divan Japonaise fame), Auriol was a humorous and charming admirer. To George Peignot, Auriol was an inventive designer of typography. To the Larousse and Enoch publishers, he was their premier book and cover designer for many years. Indeed, George Auriol was all of these things during his lifetime, and more.

"Enthusiasm was his preferred condition," said Donnay. His energy and productivity were dramatic. As a writer, he produced hundreds of short stories, articles, and poems. He published more than twenty books.

As an artist, he did numerous pictures for journals, theater programs, menus, and book covers. In addition, he created watercolors, woodcuts, and lithographs, many of them appearing in art magazines and portfolios. As an innovator of book ornamentation and typography, his designs contributed strongly to the rebirth of book printing and decoration. He created about 200 sheet music covers over a period of thirty years. His monograms and cachet designs were commissioned by some of the best-known artistic, literary, and political people in France.

During all his productive years, he read assiduously, wrote literary criticism, and expounded freely on all he read. No one was spared his monologues. In the last fourteen years of his life, he lectured and taught at a Parisian school for book printing and design.

George Auriol was not his real name but one he invented when he decided to become a writer. He was raised in modest surroundings in a small town and went to Paris at age twenty when his first story was published there.

Physically, he was quite small in stature, blond, blue-eyed, and always wore a "funny" hat. But his personal presence was far larger in size. When he entered a room, people quickly knew he was there for he commanded attention. He was described by many good friends—and not-so-good friends—as being talkative, spontaneous, impetuous, humorous, and argumentative. He could be all these things in the course of one conversation.

When Auriol came to Paris in the early 1880s, he joined the artistic scene that was Montmartre and the Chat Noir cabaret. His friends were young artists and literary people, many of whom became famous. He was involved in the color revolution in print-making, the Japonisme and Art Nouveau movements, and the rebirth of book design and production in France.

I became interested in George Auriol while conducting research on Henri Rivière. While they were close friends for over twenty years, their personalities were exact opposites. Whereas Rivière chose to remain in the background of the art scene in Paris, Auriol put himself in the forefront. When Rivière later chose obscurity, Auriol explored new avenues to be creative and gain personal recognition.

As an artist and a psychologist, I wanted to understand this man's behavior, in particular, its influence on his life, his art, and on those around him. On one hand, he represented the flamboyant, egocentric character of the period. On the other hand, his dedication and motivation in artistic endeavors far surpassed the activities of many of his contemporaries.

Auriol, today, is a little-known artist whose work is difficult to find. Most of his earlier woodcuts and lithographs are highly identifiable but rare. His work in book cover design, sheet music covers, and typography are much more numerous but seldom identified. Nevertheless, I have found the man's work original and inventive, his energies unbounding, his life colorful.

My colleague in this investigation was Marie Leroy-Crevecoeur. Her ability to follow leads, find new data, collect information and incorporate it into our story was of great benefit. She also contributed portions of the text dealing with historical material. She researched and prepared this first catalogue raisonné on Auriol. Her efforts were instrumental in making this book possible.

François Caradec wrote an article on Auriol in early 1982 revealing the man to the public for the first time in forty-five years. The information he gathered helped me pursue data more directly and opened up new areas to explore. His deep interest in the period and his knowledge of many of Auriol's contemporaries helped to obtain a better understanding of the man and his environment.

We continually hounded the Bibliothèque Nationale, the library Forney, and other Paris museums and libraries as we examined the material in their archives looking for information about Auriol. Their patience and understanding were gratifying.

Dennis Cate at Rutgers University, who has brought together one of the best collections of late nineteenth century French prints in the United States, encouraged me and gave me support when I needed it. His knowledge and guidance helped make this book a reality. His preservation and protection of the artwork of this period are commendable.

During the investigative portion of this study, we talked to many people—art historians, art dealers, distant relatives, and friends of friends—to gather the life story of Auriol. I am indebted to them for their interest in the project and the time they devoted to it.

And to my wife, Sara, supportive, understanding, and encouraging, who got to know Auriol as well as I, and who welcomed him into our family, my admiration and love.

ARMOND FIELDS

Beauvais

 N the early 1860s, Beauvais was a small but nevertheless important town. Located forty-five miles north of Paris on the main road to northern France and the coast, it was a market center. Fridays in Beauvais were busy with farmers, artisans, and customers looking to buy and sell. Located in the town was a large, well-known tapestry factory making items that were sold in Parisian stores.

The town was growing. New streets and buildings were being constructed. People were moving from the countryside to take advantage of the town's prosperity, a result of the Industrial Revolution. The townspeople themselves welcomed this activity, for it meant better economic conditions.

Within this environment Jean Huyot and Claire Marie Josephine Maillard were married on May 11, 1862. Jean Huyot was twenty-two years old, had completed preparatory school in Beauvais, and had obtained a job as tax collector and postal clerk in the local post office. Nothing is known of his parents or ancestors, but apparently the civil service was considered a good occupation in his family.

Claire Huyot was nineteen years old. She came from a family that had lived in Beauvais for many decades. Her father was an artist and artisan at the local tapestry factory. She had no additional schooling beyond elementary school.

The Huyots obtained lodgings at 34, rue du Poivre-Bouilli (today called 6, rue de Buzenval), a newer part of town occupied by younger people, some already with families.

In this class of people in small French towns, marrying at a younger age was fashionable, and in the Huyots' situation, very respectable, because Jean had a job that offered stability and security. Nor was it uncommon to have children rather quickly. The Huyots fit in well with their neighbors. Less than eleven months after their marriage, on April 26, 1863, Claire Huyot gave birth to a baby boy they named Jean Georges.

While little is known of Jean George's early life some evidence suggests that he was raised in a close and loving household. In fact, he was probably overly protected by his mother. Jean Georges was fair, blond, blue-eyed, and very small. As he explored his street and played with neighborhood friends, Jean George's small stat-

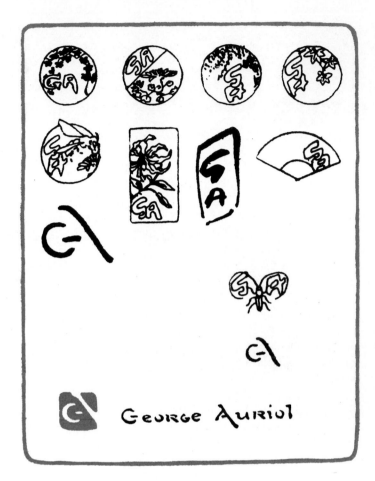

George Auriol

sphere, his parents were supportive, his mother ever present to come to his aid.

By 1869 Beauvais was becoming a small city, already over 20,000 in population, an important local market and manufacturing center. At the same time, however, the French government was making threatening gestures toward Prussia. Prussia had beaten Austria in the Seven Weeks' War and had become the head of the German states. Emperor Napoleon III did not want Prussia (and Bismarck) to become stronger and looked for a way to start a war. A series of diplomatic moves created a crisis, and France declared war on July 19, 1870.

Both countries entered the war with enthusiasm, but France was unprepared. In a series of battles, the French were defeated at Metz and at Sedan. The French then deposed Napoleon and prepared to defend Paris. After some months of fighting, Paris surrendered to the Germans. The war ended officially in May 1871, less than a year from its inception.

Beauvais, being close to Paris, was considered a key position by the Germans. They occupied the town and used it to supply their troops attacking Paris. It did not take long for Beauvais to feel the effects of occupation.

During this period, most of the local business and commercial activities continued, but in a subdued way. Schools were still open; Jean Georges continued his education. The post office was operating, so Jean Huyot was able to work and maintain his family. But more difficult times occurred after the war was over and France attempted to reestablish its government.

In April 1871, a small group of revolutionaries, appealing for freedom, democracy, and anticlericalism, attacked the established institutions of Paris—the government offices, the schools, and the churches. Many hostages were taken, including the Archbishop of Paris, and many "undesirable" people were shot. The city

ure made him appear younger than he actually was. In the usual interplay of childhood games, he was picked on and teased by his playmates. There were compelling reasons for his mother to watch over him in such a protective fashion.

This relationship between mother and son continued even as Jean Georges entered school. Not surprisingly, he was one of the smallest in his class and he remained so throughout his school days. However, he was also a very intelligent child who performed well in school. What he lacked in physical presence, he more than made up for in intellectual abilities. In this

was in a state of chaos. The French government asked Bismarck to help them put down the insurrection. With the aid of German troops, the Paris revolutionaries were defeated.

The Commune lasted 73 days. Thirty-five thousand Parisians were shot and 40,000 arrested. French governmental control was almost nonexistent.

Beauvais felt the backlash of the Commune. For quite a while, Paris as a marketing outlet ceased to exist. The government couldn't handle its own affairs, let alone the affairs of towns like Beauvais. But, as often was the case when crises of this kind occurred, the local authorities of the town maintained order and attempted to maintain their ordinary daily activities. Many necessities were limited; many of the usual bureaucratic procedures were temporarily "frozen," but Beauvais managed to come through in a reasonable manner.

The Huyot family also maintained their lives during this period of turmoil. Jean Huyot still had his post office job—he had now worked there for almost ten years. The security of his position and the rapid rejuvenation of the French economy lifted the spirits of the Huyots, and they looked forward to a more prosperous future. Jean Georges continued his excellent performance in school and demonstrated the first examples of his later literary abilities. He loved to read and to write.

To compensate for his small stature, Jean Georges became gregarious and talkative, a quite legitimate way to gain attention and recognition. It is likely his gregariousness was also an attempt to overcome the strong protective posture of his mother.

In the latter part of 1873 after a period of more than ten years, Claire Huyot became pregnant again. Her attention gradually turned toward the coming of her second child. Jean Georges realized his mother's protective behavior was waning. In 1874, when Jean Georges was eleven years old, a second child was born

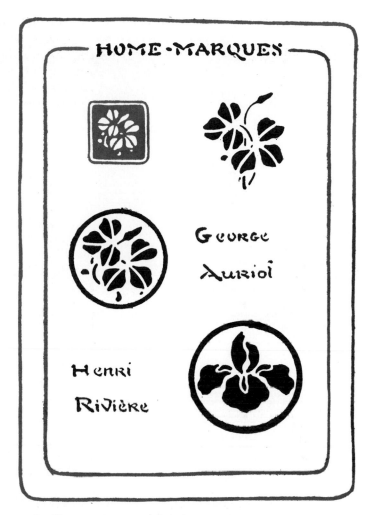

to the Huyots; they named their second son Maurice.

One of the first things Jean Georges noticed was that his mother took care of him less intensely. On one hand, he enjoyed his newfound freedom. On the other hand, he was disappointed that she was less interested in meeting his needs. As the baby established more of a role in the family, Jean Georges developed more traits that would focus more attention on him. One way was to perform well at school. Another way was to become more of a "center of attention" among other people. Jean Georges

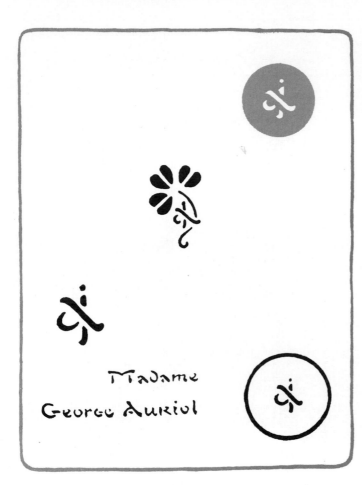

Madame George Auriol

changeable person to colleagues, friends, and acquaintances—open, friendly, humorous to some, argumentative, blustery to others; eloquently literary to some, a busybody to others; an artist who drew beautiful, Grecianlike women, but who gave them distant respect in real life.

In many ways, Jean Georges was an unpredictable adolescent, and probably vexed adults and his peers often. But because he was usually friendly, bright, inventive, and creative, he was acknowledged and accepted.

He entered the local secondary school in Beauvais and continued to do well academically. Reading and writing were still his favorite subjects, and he spent hours on them. Interestingly enough, he evidenced no interest in art during these formative years, other than to read about it.

By 1880, a rejuvenated France was establishing itself as one of the leading industrial nations. It had spread worldwide by colonizing in Africa and Asia. Its literary and artistic accomplishments made the country, and particularly Paris, the center of culture in Europe.

The Huyot family flourished as well. Jean Huyot had risen within the bureaucratic ranks of the post office and was ready to assume a position of leadership. Maurice was now in school. Jean Georges had graduated from secondary school and was pursuing his literary and writing interests. While other families may have wanted their son to choose a particular profession or become an apprentice to some local entrepreneur, Jean Georges was given a choice. He had no specific job, but wrote articles and short stories, though nothing was published at this time. His literary interests, particularly the Parisian publications, probably started him thinking seriously about going to Paris to pursue his interests.

In 1881, when Jean Georges was eighteen, his father was given a promotion as postmaster of Nantua, in Ain province, about fifty miles

exaggerated his outgoing demeanor by displaying uninhibited behavior in the company of peers and adults.

The changing role of the boy's mother had a significant impact. He had obviously looked to her for much needed fulfillment for many years. He tended to idealize her as an example for most women; at the same time, he feared her. The loss of her attention (and love) hurt him. Her discipline "protected" him. She was hard to approach, and he was too shy to try.

These feelings and impressions helped to mold the personality that became so creative in future years. They led him to display a

from Lyon. This major change for the family, who had lived in Beauvais for 19 years, was followed less than a year later by yet another move. Jean Huyot was transferred to Lyon. And not long after, in 1882, he became head of the post office in the small town of Villiers-Cottêrets in Aisne province, not far from Beauvais. Jean Huyot and his wife lived in Villiers-Cottêrets until they died. They are buried in the local cemetery there.

Jean Georges accompanied his parents to Nantua, to Lyon, and then to Villiers-Cottêrets. While in Lyon he wrote some articles for a number of small magazines. These articles were humorous and satirical in content, and Jean Georges invented some imaginary, fantasy characters in them, but the events or situations may have been autobiographical.

At about this time he selected a new name—one, he felt, that was more fitting an author and possibly more suited to his personality. There is some debate as to how he chose the name of Auriol. In some of his early stories, he wrote of a happy and carefree character called Jean Loriot. Loriot or l'auriol was the name of a bird. It is possible he took his name from that character. He changed his first name by dropping "Jean" and eliminating the "s" from Georges.

More likely, though, George took his new name from a celebrated clown called Auriol who performed during the second empire. The clown died in 1881; he was known for his "capers" and his funny hat covered with bells. Because of his literary background, George was surely familiar with the clown, and since he was writing primarily humorous and satirical articles, the name was appropriate.

George continued his literary efforts in his new home in Villiers-Cottêrets. It was 1882, and one new publication making a hit with younger literary people was the *Chat Noir* journal, which came out each Saturday and was filled with short stories, poems, and drawings

George Auriol, taken shortly after his arrival in Paris

by the editors and customers of the Chat Noir cabaret in Montmartre.

Auriol submitted his short stories to the journal, and after some failures, one of his articles was published in the August 25, 1883, issue. Encouraged by this success, and feeling the need to leave home and be on his own, he went to Paris.

Auriol's gregariousness, his literary displays, and his overall behavior quickly influenced the people he met. In the space of four months, from September to December 1883, he obtained a job at the publishing house of Marpon and Flammarion, found a comfortable place to live, met the important people at the Chat Noir cabaret, and was hired as an editor for the journal. George Auriol was ready to take on Paris.

Montmartre

N September 1882 at the Chat Noir cabaret in Montmartre, Henri Rivière, the young editor of the *Chat Noir* journal, talked about some short poems and fantasies he'd received from a little town called Villiers-Cotterêts and signed by a George Auriol. "One afternoon, when I arrived at the Chat Noir, Salis said to me, 'Do you know who this is?' and he introduced me to a fair-haired young man with a pleasing face, wearing (to my surprise) a top hat. Afterwards, I heard him make fun of the inconvenience and ridiculousness of this headgear. He was seated in front of a beer and he smiled. 'It's George Auriol.' "

George Auriol entered the world of Montmartre and the Chat Noir milieu among such people as Rodolphe Salis, the founder and operator of the Chat Noir cabaret; Henri Rivière, his very young editor of the journal; and other personalities such as Eugène Grasset, Steinlen, Willette, Allais, and Jules Jouy. Besides being deeply involved in the arts and interested in displaying them, the unique feature of this group was their youth. Salis was 32 when he opened the Chat Noir; Steinlen was 24; Willette, 26; Allais and Jouy were 28; Grasset was the oldest, at 38; and Rivière was only 19.

Other artists who frequented the Chat Noir and often contributed to the journal were Pille, Fau, Caran d'Ache, La Gandara, Somm, and Lunel. The writers and poets attracted to the cabaret were Goudeau, Lebeau, Lorrain, Rollinat, Bloy, and Ponchon. The inventor Cros tried out his experiments on his friends at the cabaret. Some musicians who wrote and performed at the cabaret were Satie, Trinchant, Fragerolle, and de Swiy.

Montmartre was the center of this attraction. In 1860, the commune of Montmartre became a district of Paris (the 18th arrondissement) with a population of about 30,000. It attracted people who sought a more countrified atmosphere. Working people liked it because the living quarters were cheaper. Artists were attracted not only because things were cheaper, but because the light was better "on the hill." Montmartre was still somewhat cut off from the rest of Paris; no public transportation went that far, and farms and fields and working windmills could still be found in the area.

The writers of the period painted an idealized picture of the Montmartre artist, one who was nonconformist, happy-go-lucky, and friendly. Yet one could also be shoulder to shoulder with personal misery. While Montmartre may not actually have been such a place, it nevertheless did quickly become a pleasure

area of Paris, a center for popular entertainment. It also attracted the petit-bourgeois, young working people, and domestic servants.

Pleasure, however, turned to death in 1871, when the Commune emerged after Germany's defeat of France. The Commune was said to have started in Montmartre where the Parisian "revolutionaries" lived and preached their philosophies amid much fighting and killing. It became their last holdout against the government troops. Thus, Montmartre became a "sacred" place to the political and social revolutionaries of the time (and those with a revolutionary spirit).

The image of Montmartre took on new form when the great basilica Sacré Coeur was built on the hill overlooking Paris. Construction of the church (and its political debates) attracted and influenced the poets and artists of the time. Montmartre became a symbol against the art establishment of the city–the Institut and the Ecole des Beaux Arts. Beauty no longer meant romantic landscapes, the architecture of Rome and Greece, or the Barbizon school. Thanks to the writing of Zola, beauty was found in the people themselves and in their environment. And so Montmartre attracted Impressionists like Renoir, Cezanne, Degas, and Pissarro, as well as their followers Signac, Van Gogh, Raffaelli, Luce, and Cross.

By 1880 Montmartre had doubled in size. It had attracted better shops and commercial enterprises, and along with those, a better class of people. The cabarets were still very popular, but they now included customers from the better parts of the city. Still a great place for aspiring artists, Montmartre was a fashionable place to be as well.

To this community came Rodolphe Salis in 1881. Salis was the son of a wine merchant of Chatellerault. Initially he wanted to become an artist but decided against it because it "would not feed him." He opened a small boutique in Montmartre in an area where artists and stu-

Rodolphe Salis, director of the cabaret Chat Noir

dios were numerous. There he met and became friends with Emile Goudeau, a young writer, who persuaded him to open a cabaret. Goudeau brought all his friends there. They called it the Chat Noir. The cabaret opened in November 1881 at 84, Boulevard Rochechouart.

The Chat Noir cabaret was unlike any other cabaret in Montmartre and Paris. Its clients and performers also contributed to the decor. The stained glass frontage was created by Grasset. Over the door hung a black cat on a silver crescent of the moon, cut out of sheet metal, designed by Willette. The wall hangings

and wallpaper were green, and the paneling consisted of glazed doors of the Louis XIII period. Inside a big country fireplace with columns carried a mantel adorned with copper pottery. Over the mantel hung a sculpture of a sun with golden rays with a cat's head in the center, made by Freniet. Chandeliers of wrought iron were designed by Grasset. In the back was a little room sarcastically called "the Institute," where the "regulars" ate their meals. Beer was served by waiters dressed as academicians. Every evening the patrons had an opportunity to read poetry, play or sing their latest compositions, and discuss topics on art, literature, politics, government, and humor. The Chat Noir became the meeting place for those in Paris society who enjoyed the "freedom" of the moment.

The literary and artistic involvement of these people led to the establishment of the *Chat Noir* journal. Its first issue was published in January 1881 with Emile Goudeau as its first chief editor. It was nicely printed on four large pages. The logo at the top of the front page was a black cat in front of the windmills of Montmartre, drawn by Henry Pille. The journal published news, poems, articles, short stories, and drawings—all contributed by the artists who frequented the cabaret. In a short while, the journal became very popular and was available in and outside of Paris.

Auriol fit right into the Chat Noir environment, and his personality and literary abilities obviously influenced Salis. In the December 11, 1883, issue of the journal, just four months after he arrived in Paris, Auriol's name appeared as an editor of the paper (Secretary of Administration), a position he held for ten years.

At the beginning of their friendship, Rivière described Auriol as a "very gay personality—one who overstated all his proposals and was paradoxical—often self-contradictory, whose personality characteristics didn't seem to go together." Other friends

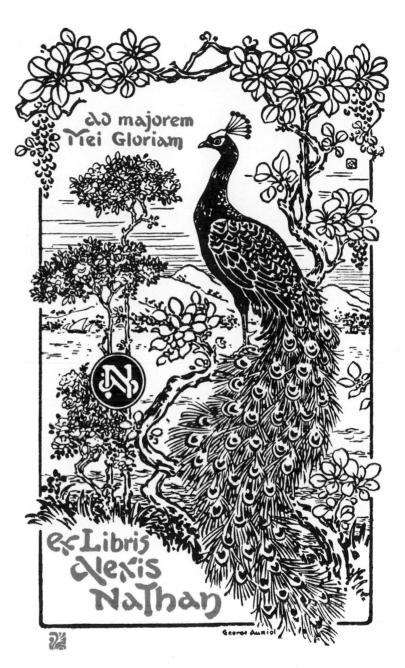

The Chat Noir masthead, designed by Pille, featuring Allais as editor-in-chief and George Auriol and Albert Tinchant as editors

and colleagues spoke of him thus: A short man, clear blue eyes, a little hat worn to be noticed, spontaneous, emotional, impetuous and enthusiastic. He argued a lot, changed his mind a lot, changed feelings quickly, but held no grudges, was not malicious nor mean. He was also joyful, always talkative—even while working, was funny, made jokes, had a good imagination, a story-teller full of fantasy. He read a great deal, everything he could get hold of, and pressed his literary knowledge and opinions on the people around him. Auriol seemed to have a "social" self and a "private" self. He was really a shy person, was concerned about his size and how to overcome it, and he overreacted to gain attention. He was also very shy with women.

All agreed that Auriol was a highly creative, hard worker who spent long hours on his projects and who worked on many projects at once. His energy was boundless, and "enthusiasm was his preferred behavior."

In the tolerant Montmartre and the Chat Noir environment, George Auriol could indulge in the personality he wanted to display to others. He was only five feet three inches tall and of slight build, but his gregarious, outgoing manner made everyone aware of him. His confident, erudite, talkative nature impressed people. Auriol had found a "home."

Not all his friends, however, accepted his enthusiasm and jocularity. He joked in excess, especially when it made other people uncomfortable, and it made others angry at him. His sometimes argumentative stance, often on insignificant issues, caused some to avoid him. His volatile emotions, happy one moment, angry or upset the next, made him difficult for people to work with. Such personality traits were probably designed to compensate for his sensitivity to his small stature and the overly protected way he had been raised. While these traits obtained recognition for his artistic efforts and spurred his creativity, they also made him a difficult person to know and his own personal

goals more difficult to obtain.

From all indications, Auriol preferred the company of men. He appeared to be somewhat in awe of women, although he was attracted to them. In his early writing (and drawing), he seemed to idealize women but remained distant from them.

The meeting with Rivière became an important one for Auriol. Henri Rivière was a year younger than Auriol, but had been working for Salis and the Chat Noir for over a year. He, too, was a good writer and an avid student of literature, but he was an even better artist. He had been drawing, painting, and sketching since the

age of six and had developed a "quick" hand at portraying the people in the streets. In addition to his editorial duties, he drew pictures for the journal. Rivière was, in many ways, the opposite of Auriol. He was a quiet person, often preferring to remain in the background. He was not a social member of the Chat Noir group, nor did he interact with them outside of the cabaret. He was a meticulous worker, involved in the detailed nuances of art, compulsive, and not easily influenced by those around him.

The two men liked one another immediately and quickly became close friends. As editors of the journal, they worked together constantly. But they also spent time together outside the Chat Noir, visiting museums and galleries all over Paris. But, more importantly, Rivière interested Auriol in sketching and drawing and taught him the fundamentals of the technique. With great enthusiasm, Auriol accepted the lessons and practiced incessantly. It is not surprising, then, that Auriol's style emulated Rivière's for the first few years of his apprenticeship. When Rivière went out to draw the people and the sights of Paris, Auriol went along and gained experience in this medium, concentrating especially on the well-dressed Parisian women.

Besides teaching Auriol drawing, Rivière also introduced etching, brush and pen drawings, and watercolors to his avid student. Watercolor was Rivière's favorite medium and became Auriol's as well. Auriol obviously had a great deal of artistic talent and developed rapidly. In fact, Auriol's first picture appeared in the *Chat Noir* journal in 1886, about two years after he started drawing. It portrayed a well-dressed Parisian woman in a somewhat sketchy line drawing, but the mastery of proportion, shading, and line efficiency was already apparent.

Auriol, Allais and Riviere having lunch at the Chat Noir

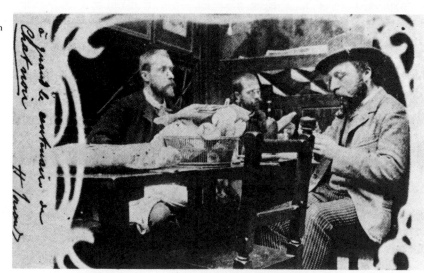

Auriol's first published drawing in the Chat Noir journal in 1886

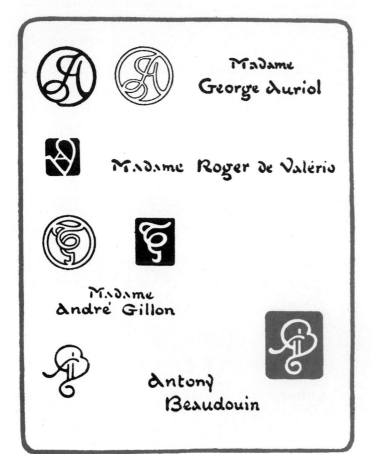

Madame
George Auriol

Madame Roger de Valério

Madame
André Gillon

Antony
Beaudouin

not to mention the numerous side trips to book stores and fellow artists' lodgings.

Just about the time that Auriol had established himself as an editor at the *Chat Noir* journal and embarked on a new profession as an artist, he was drafted into compulsory military service for three years. In 1884 he reported to the training camp at Soissons and joined the 67th infantry regiment. Auriol continued, however, to contribute articles and poetry to the *Chat Noir* journal. He could not continue as editor, though, and Albert Tinchant took over temporarily.

Apparently, Salis had some association with a high-ranking officer in command at the camp and, upon a request by Auriol, had a piano delivered to the soldiers' recreation hall. Ordinarily, it would have been impossible to have such a musical instrument available. This association also helped to reduce Auriol's time in the army. Thanks to a Salis petition that outlined the need for Auriol at the Chat Noir, Auriol was released after ten months of service. By September 1885, Auriol was back as an editor of the journal.

During the time that Auriol functioned as an editor, he continued drawing and painting, writing articles and longer pieces. Two other major influences had an impact on his creative direction and execution.

Eugène Grasset was already a well-known artist in Paris in the early 1880s. He had helped Salis in the initial design at the Chat Noir. While he was not a frequent patron at the cabaret, Grasset was quite friendly with the artists at the Chat Noir and worked with them often. They were aware of Grasset's printing innovations. By 1883 he was doing photocolor relief printing in collaboration with Gillot. Grasset did the watercolor design, Gillot did the color illustration for a book. By 1886 this collaboration created quality color "prints" with photo illustrations for the journal *Paris Illustre*. As a decorative artist, Grasset also created designs

When Auriol came to Paris, he was fortunate in obtaining a job, as a clerk, in the publishing house of Morpan and Flammarion. Auriol's first lodgings were at 17, rue Racine, directly across the street from his employer, in the Latin Quarter, a good distance from Montmartre. He did not leave the job when he started to work for the Chat Noir, so his day was filled with transporting himself from home to work, to the Chat Noir and back home again,

for furniture, tapestry, stained glass windows, textile fabrics, and typographical printing.

Grasset and Auriol met at the Chat Noir and they exchanged artistic ideas. Their conversations led to experimentation and sparked Auriol's interest in typography and ornamental design. To some extent, Auriol had obtained some knowledge of these subjects as editor of the *Chat Noir* journal, but Grasset's association focused his interest on them. With his typical enthusiasm, Auriol learned all he could about them. As he became more involved in his own magazine illustrations, he had the opportunity to practice what he learned.

Auriol found that the best way to make titles—his first attempts were titles for songs and poems—was to hand letter them himself, as they could be reproduced no other way. Unlike other artists working in the same area, Auriol used a brush rather than a pen point.

The other influence was the continued popularization of Japonisme during the middle 1880s. In 1856, Felix Bracquemond introduced Hokusai woodcuts to the French public. They were copied from albums and used for ceramics. By the late 1860s, many French artists were incorporating Japanese motifs into their work—Monet's prints (and especially his portrait of Zola); Whistler, Tissot and Degas's portraits of Western women in kimonos are examples. Oriental tea shops were opened in Paris, and Parisian department stores featured Chinese and Japanese sections.

In 1872, Philippe Burty coined and promoted the phrase "Japonisme." It caught on rapidly. Louis Gonce, in 1883, put on a sizable exhibition of Japanese art, and it caught the interest of many collectors. Gonce also published a book, *L'art Japonais*, that caused a great deal of interest in the art form. However, the one person who popularized the movement and caught the eye of artists was Sigfried Bing who opened a shop at 11, rue de Provence, featuring woodcuts, lacquers, sword guards, paper

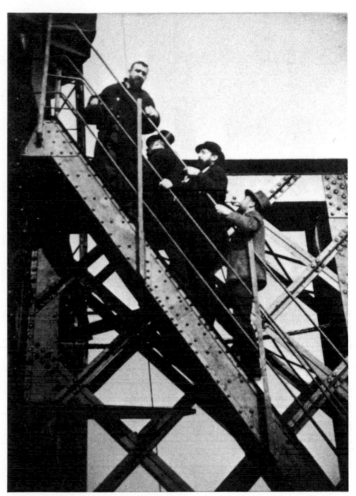

Salis, Riviere and Auriol climbing the stairs of the newly completed Eiffel Tower

stencils, and stone-rubbings. The Japanese art exhibit by Van Gogh at the Café de Tambourin in 1887 consisted of prints from Bing. In 1888 Bing published a periodical called *Le Japon Artistique*, which made many more people aware of Japonisme.

During this time Rivière became so interested in the Japanese woodblock technique that he decided to teach himself the whole print-making process and apply his Brittany

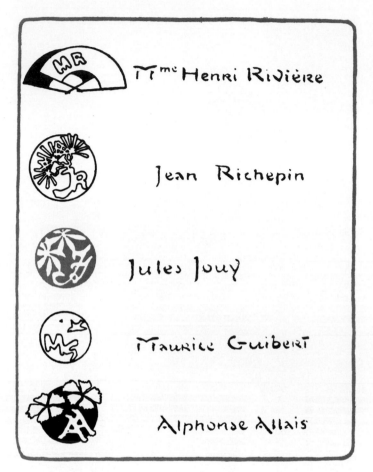

scenes to it. Auriol became involved in this, too, although not with the same degree of commitment. Still, he learned how to do woodcuts and produced several editions. But what influenced Auriol more were the Japanese designs, landscape and flower treatment, and the simple lines. He immediately incorporated these features into his own work and utilized them for many years.

Thus, by 1888, after only five years in Paris, Auriol had become quite proficient as an editor of a journal, a writer of short stories and poems, and an artist who drew, sketched painted watercolors, and cut woodblocks. And, in all of these media, he was recognized as a man of great talent.

George Auriol

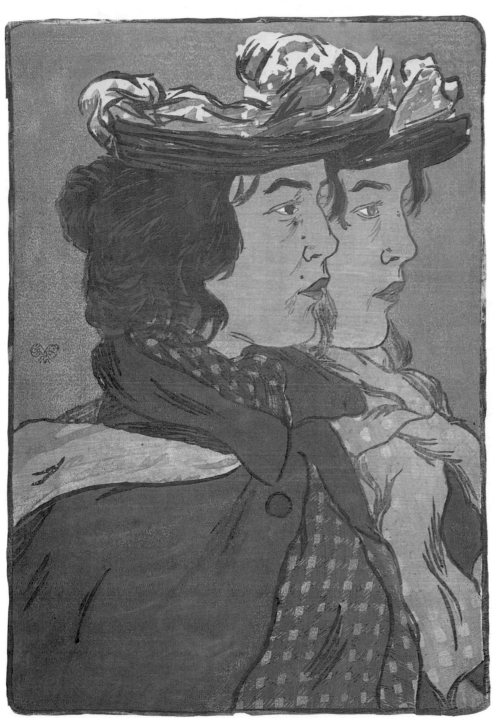

The Twin Sisters,
woodcut, 6 colors,
24.5 × 35 cm.,
1893

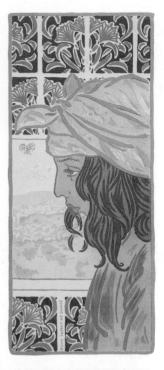

Selim, enfant de Damas, lithograph, 10 colors, 35.5 × 15.5 cm., 1897

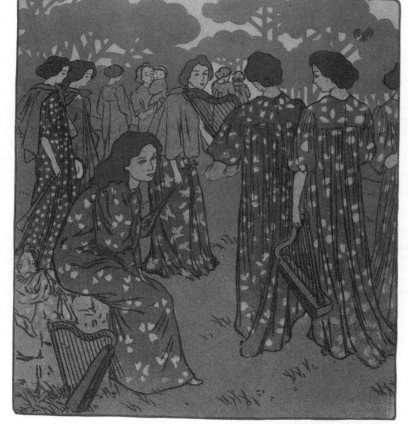

Chansons d'Ecosse et de Bretagne,
lithograph, 5 colors, 24 × 26 cm., 1895

Je veux de la poudre et des balles,
lithograph, 8 colors, 47 × 26 cm., 1897

34

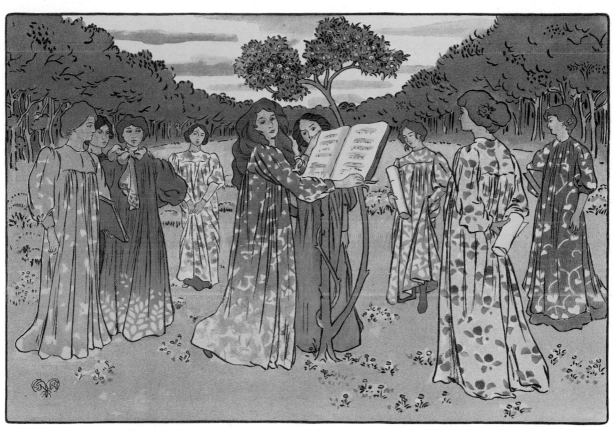

Vieilles chansons de France, gillotage in colors, 20.5 × 29.8 cm., 1898

Schéhérazade,
lithograph, 7 colors,
23.5 × 15 cm.,
1901

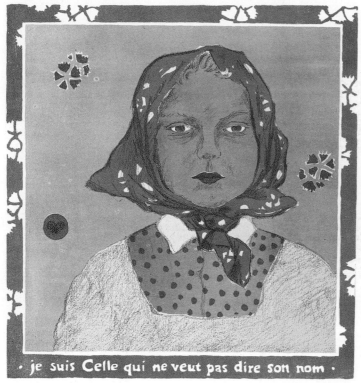

je suis Celle qui ne veut pas dire son nom

*Je suis celle qui ne
veut pas dire son nom*,
lithograph, 5 colors,
32.5 × 30.5 cm.,
1894

*Head of a Young
Lady*, lithograph, 4
colors, 23.5 × 13.5
cm., 1901

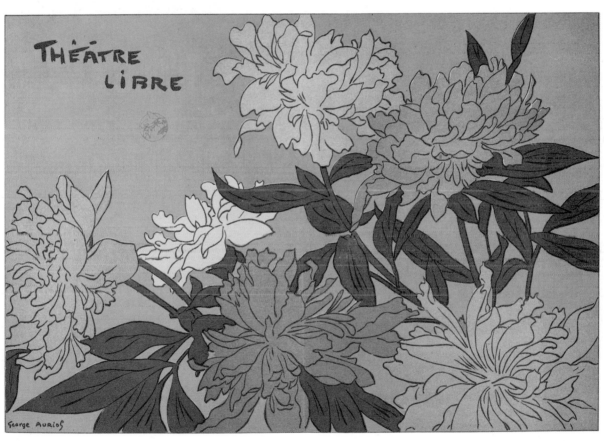

Théâtre Libre program
lithograph, 5 colors,
22.5 X 32 cm.,
1889

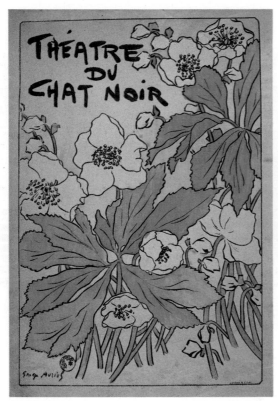

Chat Noir theatre
program, pink and
yellow bindweed, 2
colors,
photomechanical
process, 31.5 ×
22.5 cm., 1889

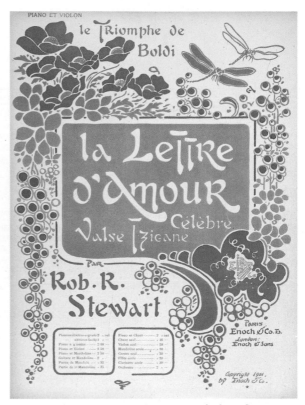

La Lettre d'amour,
lithograph, 2 color,
35 × 27 cm., 1900

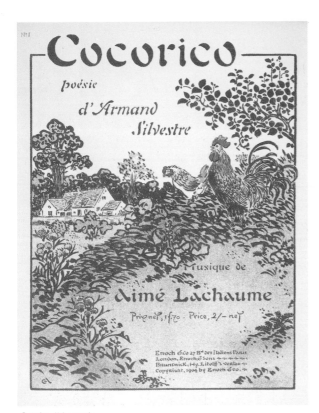

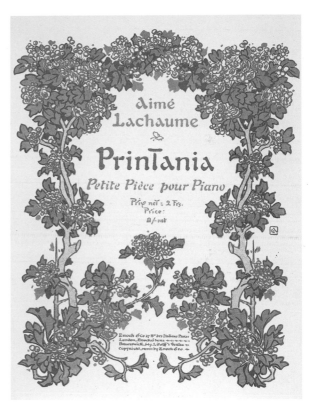

Cocorico, lithograph,
3 colors, 35 × 27
cm., 1904

Printania, lithograph,
3 colors, 35 × 27
cm., 1909

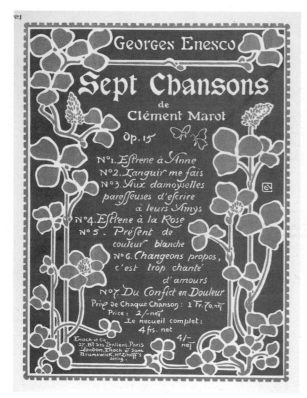

Sept Chansons,
photomechanical
process, 2 colors,
35 × 27 cm.,
1922

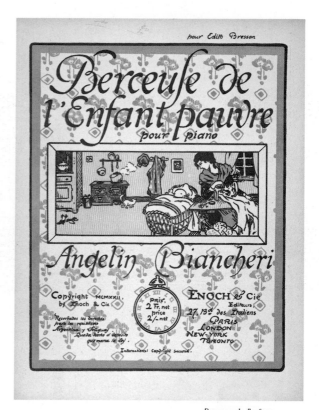

*Berceuse de l'enfant
pauvre,*
photomechanical
process, 2 colors,
35 × 27 cm.,
1922

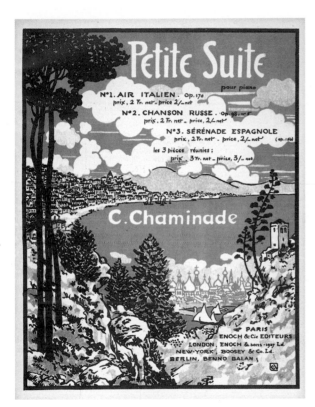

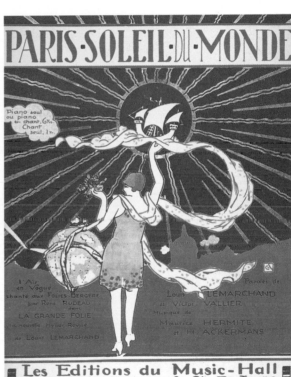

Petite suite,
photomechanical
process, 2 colors,
35 × 27 cm.,
1927

Paris, soleil du monde,
photomechanical
process, 3 colors,
35 × 27 cm., 1928
(last music sheet
cover)

Poster for "The Studio," lithograph, 2 colors, 60 × 38 cm., 1898

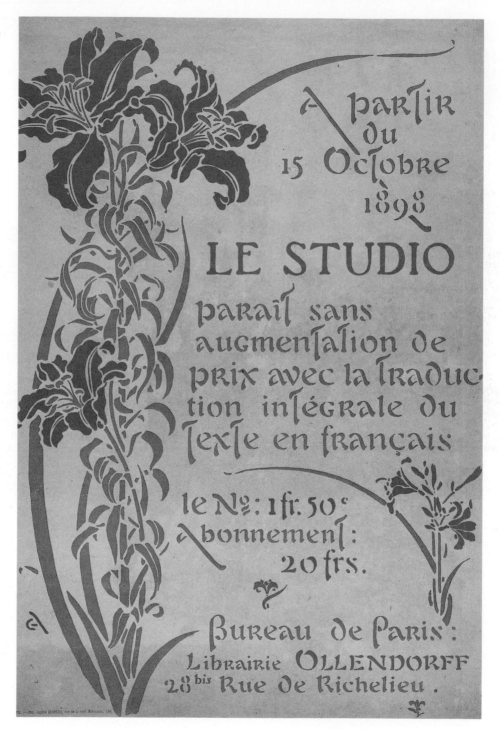

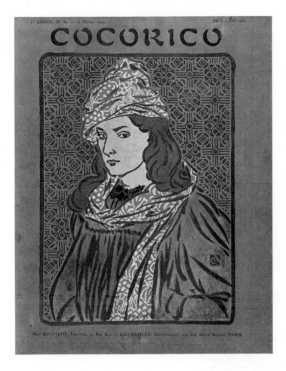

Cocorico, magazine
cover, lithograph, 5
colors, 31.5 × 24.5
cm., 1902

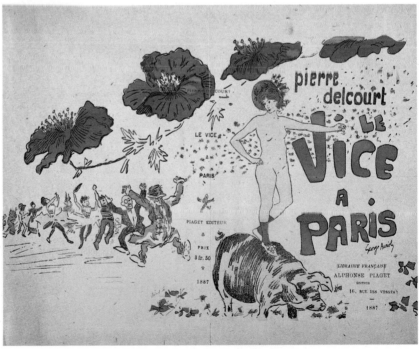

Le Vice à Paris, book
cover, 4 colors, 14.5
× 20.5 cm., 1887

Une idée lumineuse,
book cover, 4
colors, 1888

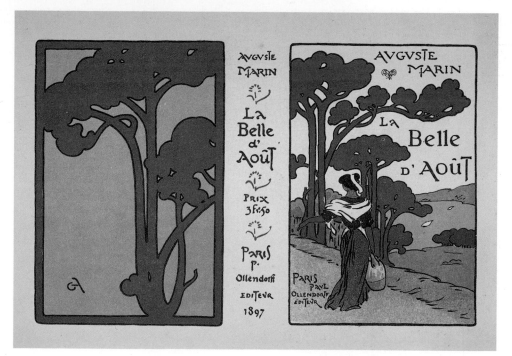

La Belle d'Août, book
cover, lithograph, 5
colors, 15.7 × 24.6
cm., 1897

Les Bucoliques, book cover, lithograph, 6 colors, 17 × 20.5 cm., 1898

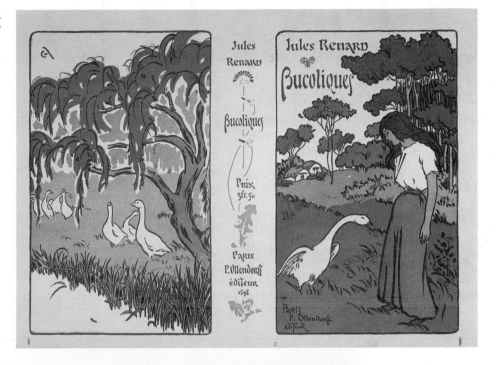

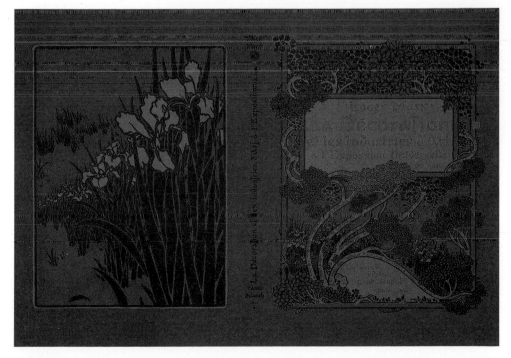

La Décoration et les Industries d'Art à l'Exposition Universelle de 1900, book cover, lithograph, 3 colors, 27 × 33 cm., 1900

Christmas card,
lithograph, 4 colors,
17.5 × 11.5 cm.,
1907

Christmas card,
lithograph, 6 colors,
17.5 × 11.5 cm.,
1916

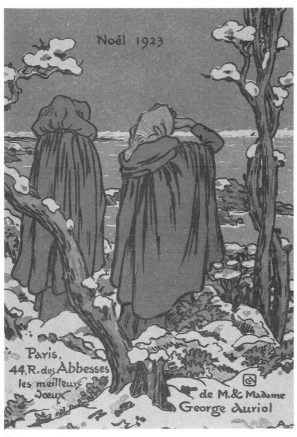

Christmas card,
lithograph, 6 colors,
17.5 × 11.5 cm.,
1923

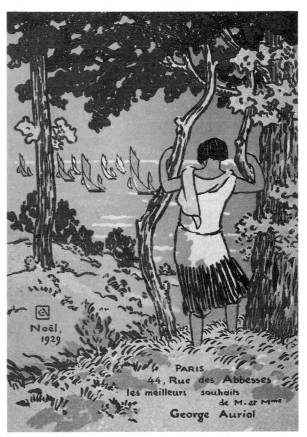

Christams card,
lithograph, 3 colors,
17.5 × 11.5 cm.,
1929

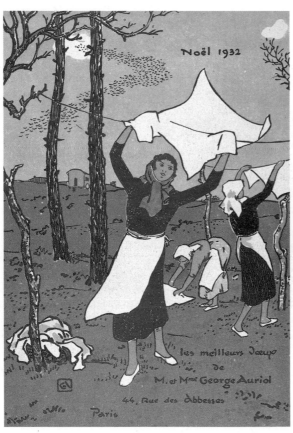

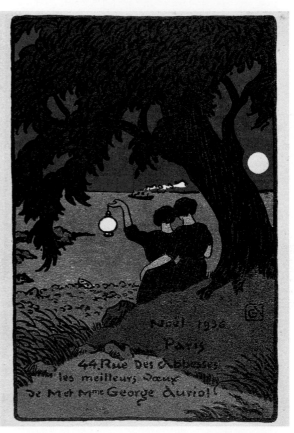

Christmas card,
lithograph, 4 colors,
17.5 × 11.5 cm.,
1932

Christmas card,
lithograph, 5 colors,
17.5 × 11.5 cm.,
1936

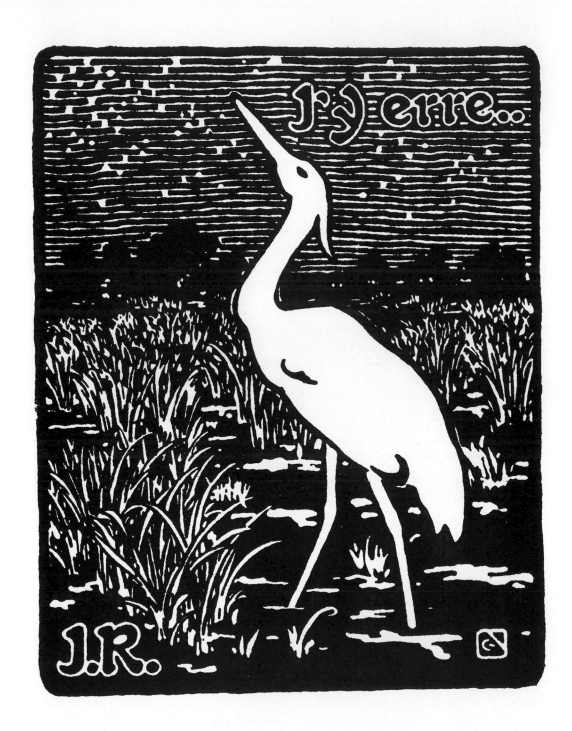

Chat Noir

ARE photographs of Auriol show a somewhat lean looking young man in 1883; by the late 1880s, he has gained weight to the point where his friends described him as "plump." Descriptions of his behavior have changed little. Those who were his friends talked about his "capers" in a humorous, if not conciliatory, tone. Those with little respect for him talked about his irrational emotions.

Rivière relates, "He read a lot and sometimes arrived at my house with eight or ten volumes that he absolutely wanted to make me read. 'But I have no time, old man, to absorb all that. Show me the most interesting.' 'But if they all are,' he cried, and he eulogized each of them with infectious enthusiasm. He was happy to defend what he liked and allowed no contradiction."

Auriol and Jules Jouy were reported to have argued vociferously about which church door to enter. It was one of many arguments they had, and Jouy liked to take advantage of Auriol's quick emotions. Once in an effort to prove a point to his colleagues, Auriol went out into the street, accosted a stranger, dragged him into the cabaret, and used the man to emphasize his side of the argument. The man was embarrassed and angry; Auriol's companions were also embarrassed by the episode; Auriol seemed triumphant. This kind of behavior, whether condoned or condemned, was an almost daily part of Auriol's life.

One of the people who befriended Auriol was Alphonse Allais, an early habitue of the Chat Noir cabaret and a frequent contributor of articles and poems to the journal. Allais was 28 years old when they met. Allais so enjoyed the antics of Auriol that he wrote about him often, usually in an affectionate but humorous way. Their friendship became quite strong, with Allais defending Auriol when problems arose with their coworkers. This was exemplified when, through an internal misunderstanding at the journal, Auriol was removed as an editor (September 1886). However, Allais was made editor-in-chief of the journal, and the

first thing he did was to reinstate Auriol in his editorial position.

Auriol's artistic development progressed so well that, in a January 1888 issue of the journal, a full page of his drawings was published. They show people on the Parisian streets, primarily women, and all with a strong Japonisme flavor.

By 1885 the Chat Noir had outgrown its space, and new quarters were found on rue Victor-Masse. An elaborate celebration was held when the move took place. The new cabaret was decorated extensively by the participants. Salis wanted to publish a guide to the new Chat Noir and asked Auriol to design it.

New performances were also created. Rivière developed Shadow Theatre productions featuring the music and talents of some of the cabaret's performers to go along with zinc-cut images silhouetted against a large screen. Stories were written and many images were prepared for each of them. Auriol helped out on these projects, probably designing and cutting out the zinc plates. In addition, he started designing the programs for the productions, doing twelve in all, in the period from 1887 to 1889. The illustrations reflect a strong Japonisme influence.

During this time, Auriol's interest in writing continued. Besides contributing articles to the journal, he wrote some songs for the Chat Noir. Also, in 1887, he published "Les Rondes du Valet de Carreau," with music by Marcel Legay and illustrated by Steinlen. This was followed by the acceptance of a group of illustrations for a journal produced by a new local cabaret, *La Lanterne Japonaise.* The combination of writing, illustrative drawing, and title preparation obtained for him his first assignment to design a book cover, *Le Vol à Paris,* published in 1888. The following year, and in 1891, Auriol designed the inside cover (facing pages) of two books, prepared by Salis, and filled with drawings by Rivière, Pille, Somm, Robida, Fau, and Steinlen. They were called *Contes du Chat Noir (L'Hiver)* and *(Le Printemps),* and both portrayed pictures of women with floral backgrounds in the Japonisme style. But the sense of design and layout showed considerable sophistication, and the lettered typography a strong, sure hand.

When Rivière was introduced to lithography in 1889, so was Auriol. Although he did not initially care to work in lithography, he supervised the use of it on some of his early book designs. Another facet in his artistic development was the creation of monograms or cachets. Cachets, marks, and monograms used as "signs of recognition," apparently started during the Mesopotamian civilization. Cachets,

An example of a
brush and ink drawing
by Auriol, preparatory
to use in the Chat
Noir journal

A program for the Chat Noir theatre designed by Auriol

or seals, were usually an intaglio or relief engraving using the initial letters of a name. The mark was more often an animal, material, or nature representation, the kinds embossed on soap, for example. The most famous mark in France was the "fleur-de-lys" used by the French kings to identify their possessions. The monogram was most often the initial of the last name. It, too, had been known since antiquity.

In France, during the latter part of the nineteenth century, these marks of identification were used primarily to identify of manufactured products. Although such marks had been used in books since 1462, they were rarely seen in books during this period. Even though cachets and monograms were familiar to the artists of the period, not until the introduction of Japonisme in France was serious notice taken of the use of these symbols. Monograms in art were used extensively by Japanese artists for many hundreds of years. Usually, each artisan involved in the preparation and printing of woodcuts used a symbol or logo to identify his portion of the work. The primary artist also

had a logo, but it was larger in size than the others.

The French artists who were attracted to and influenced by these Japanese prints also became interested in using the monogram on their own work. It was Auriol, however, who saw the creative possibilities of making the cachet and monogram into an expressive art form all its own. Auriol's work in these small designs helped increase his identity among the art, society, and business worlds.

When Rivière and Auriol started to work with woodblocks in the Japanese manner, Auriol became interested in monograms, primarily as another form of design. When Rivière prepared and printed his first woodcut editions, he asked Auriol to design some of these logos for him to use. Auriol addressed the creative problem with his usual vigor and produced not one, but seven images for Rivière. Again, the style was Japanese, featuring Rivière's initials and his favorite flower, the iris. Rivière used them on his etchings of 1888, his first published woodcut in 1889, and on all his works thereafter.

Auriol decided to create a monogram for himself. Up to 1888, he usually signed his name on his art work. Auriol's first monogram appeared in 1889, a beetle (longicorn) within whose antennae were the initials G and A. The use of these monograms attracted a good deal of attention from Auriol's friends and colleagues. They asked Auriol to create monograms for them. His initial designs included logos for Allais, Jouy, Fragerolle, Fau, Somm, Théâtre du Chat Noir, Steinlen, and Delmet. It was not long before Auriol became well known for his monogram designs. Based on knowledge of the people for whom he ultimately did them, some money was probably made. This was especially true for the company logos he later designed and which were used for many years.

In 1890, a group of literary and theatre

people founded a private club called "le Gardénia." Allais was involved in the creation of the club, and he probably got Auriol involved as well. The group had special dinners each month for which they prepared artistic invitations and menus (usually with lithography) made by various participants in the club. Auriol created a number of these. This experience paved the way for many such designs for people and groups in future years. Some were done as specific commissions for pay, but most were created as courtesies for friends.

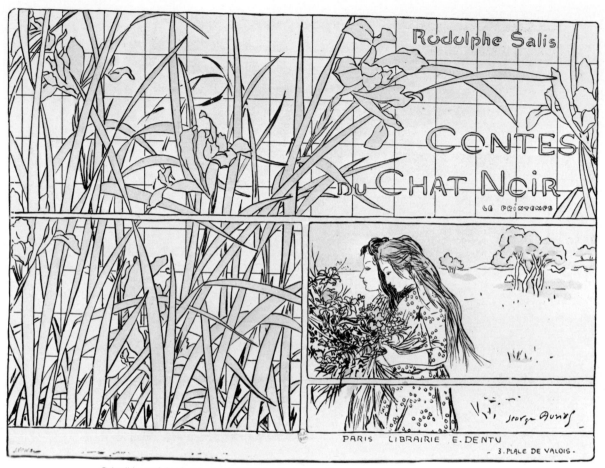

Color lithograph by Auriol, placed inside the front cover of
Salis's Contes du Chat Noir (le printemps)

By 1892, Auriol had established himself
as an accomplished writer, a graphic artist, and
a book designer and illustrator. Not only was
he known to the people familiar with the Chat
Noir but also to publishers and printers. His
time was fully occupied with these efforts; often
he worked on four or five projects at one time.

Again his career was interrupted by a call
from the army to attend training camp with the
67th infantry regiment. This lasted only from
March to April, but it offered him an opportu-
nity to get away from the pressures of his daily
work and think more about his immediate fu-
ture. The time was well spent for he returned
to the Chat Noir, his assignments, and his
friends with new ideas and new directions.
Auriol was leaving behind his learning, explora-
tory years and was about to embark in areas
where his knowledge, skills, and expertise
would serve him well, both professionally and
personally.

Brush and ink drawing by Auriol, an example of the flower designs he made for program and book illustrations

The Auriol Style and Art Nouveau

Y the middle of 1892, the Montmartre environment had undergone many changes. The windmills and empty fields had disappeared, replaced by apartment and commercial buildings. An increasing number of cabarets and show houses attracted not only the better social classes, but also prostitutes, drug traffic, and social deviates. Artists and artisans still lived in the area because it was inexpensive.

The Chat Noir cabaret was still a popular place to go, but it was no longer unique. Other cabarets had opened up, presented new shows and performers, and attracted a good deal of attention. The Chat Noir had competition now and was beginning to be affected by such business pressures.

The *Chat Noir* journal was affected in the same way. Many other local weekly magazines were being published, attracting artists and writers, offering new opportunities for exposure and, hopefully, fame. The journal's appeal had faded, and its sales declined. Rodolphe Salis, owner of the Chat Noir, was sensitive to these changes. He had been operating the cabaret and journal for over ten years and had lost some

of his interest in it. He thought seriously about selling.

Alphonse Allais was the journal's chief editor for a number of years. In 1891 he resigned from the position, but still worked there. He wanted to establish his own publication, and, indeed, did help Fernand Xau start a new journal in 1892. From the time Allais resigned as editor, the *Chat Noir* journal did not function as well.

Auriol was still an editor and contributor of the journal (writing and drawing) and was quite involved with it. He had developed a close friendship with Allais, so when Allais heard about the possibility of Salis selling the Chat Noir, he talked to Auriol and the two of them agreed to make Salis an offer. In early 1893, they offered 5,000 francs to Salis for the cabaret, but the offer came too late. Salis had just sold it to Charles Gallot. Allais and Auriol then tried to buy the journal, but no deal was made. Emile Boucher bought the journal. Auriol retained his job as editor. Allais was very angered by these events.

Local elections in Paris were to take place in August. In a satirical and joking mood, Auriol (and others) invented a candidate – Captain

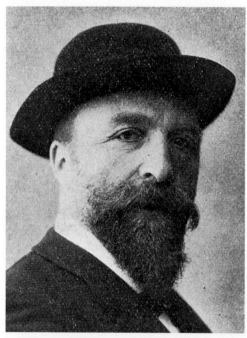

Auriol in the early 1890s

editor, the friendship between him and Auriol diverted Auriol's loyalty to Allais. Allais returned the favor by promoting Auriol's activities, personal interactions, and behavior, often in writing.

In September, one month later, a new illustrated weekly was published, *La Vie Drôle*, with Alphonse Allais as director; Henri Jouard, administrator; and George Auriol, editor-in-chief. Unfortunately, the journal lasted for only eleven issues.

Near the end of 1892, Auriol sought better living quarters. He had been in the same apartment since coming to Paris. He needed more space, especially work space, and he wished to be closer to Montmartre. His various jobs and commissions obviously generated enough money to afford these needs. He found an apartment at 44, rue des Abbesses, on the fourth floor, the view overlooking a good part of Paris. In a book by Louis Morin, written in 1893, Morin describes Auriol's new place and Auriol's artistic ability. Morin was conducting a tour of artists' living quarters with friends.

At the hour when M. Jefferys and his friends arrived at Montmartre the cabaret of the Chat Noir was empty—a first surprise for M. Dupont, who imagined that all the young men who frequent it spend their time there in drinking bock and absinthe. It was suggested, therefore, to look up the artists in their studios, and it was in that of M. George Auriol that their visits began.

The amiable secretary of the editorial staff of the Chat Noir *journal lives in the Rue des Abbesses, on the fourth floor, with a balcony which overlooks all Paris, and above which floats a blue Japanese flag. His studio is a large room, very soberly decorated, with choice and fragile Japanese objects, and reproductions from old Flemish masters and Botticelli, for whom M. George Auriol has a special cult.*

Cap—to run for office on an antibureaucratic, anti-European ticket. They devoted much time and energy to popularizing this candidate, using the *Chat Noir* journal. Just before election day, they even published a picture of him, an episode that upset the journal's new owner. On August 26, Auriol was relieved of his editorial duties. A month later, he wrote his last story for the *Chat Noir* journal.

Auriol usually demonstrated a great deal of loyalty to Salis. Salis had hired him upon his coming to Paris, had supported his writing, and given him the opportunity to develop his artistic career. When Allais became chief

In long necked vases here and there were bloom-
ing violet irises and rare orchids — the chief lux-
uries of a painter who is, of all men, a lover
of flowers, and who derives from them such
powerful decorative effects. The woman and
the flower, in fact, are the two preferred models
of George Auriol, and they most often suffice
him for those graceful and distinguished com-
positions which have gained him his great suc-
cess. In looking at M. Auriol's drawings one
thinks in spite of himself of those delicate poets
who need but the slightest motive, a fugitive
thought, a vague impression of landscape, a
graceful feminine gesture caught on the wing,
in order to chisel out a marvelous sunset, one
of those pieces of verse which move your soul
softly in unison with that of the poet, whose
charm is so subtle that, better than a long
poem, it reveals to you the power of art — that
art to which the subject counts for so little!

And, in fact, Auriol's drawing is that of
a poet; he has never considered illustration as
a profession, and he would certainly recoil from
the hard necessities of illustration, such, for ex-
ample, as that of conning a text page by page
in order to make visible to the reader the per-
sonages imagined by the author. He needs a
freer field, where his personality can develop
itself at ease, with no obligation to obey the
requirements of text. This is why he succeeds
better than anyone else with the covers of books,
magazines, posters, tailpieces, friezes, titles,
borderings.

It is not surprising to find that the cover of the
book and many illustrations in it were done by
Auriol. This was probably the first written
praise of Auriol and his work.

Overall, 1893 was a very important year
for Auriol. He had his first book published,
Histoire de Rire, by Flammarion, the people who
had given him his first job in Paris. The book

consisted of numerous short stories, all hu-
morous in nature. Seven more books followed,
one each year, all published by Flammarion.

In April Auriol participated in his first art
show. He was invited to exhibit examples of
his work among the Société a Peintres-Graveurs
at the Durand-Ruel gallery. Included in this
show were works by Buhot, Chéret, Guérard,
Jeanniot, Toulouse-Lautrec, Rivière, Whistler,
and Zorn. Auriol submitted two watercolors,
various monogram designs, seven woodcuts in
color, and a design for a fan, prepared for
Maurice Donnay. The works are strongly
influenced by the Japonisme movement and by

61

experimentation. In preceding years, Auriol had occasionally done images which had been lithographed, such as the programs for the Théâtre Libre. As Rivière's interest in lithography increased, so did Auriol's. He spent some time working in the shop of Eugene Verneau and practiced with color lithography. The result was his first full color lithograph edition, *Bois frissonnants*, published by l'Estampe Originale, a very prestigious publisher and distributor of the day. Reaction to it was positive, and Auriol decided to explore the media further, especially with possible use in book cover design.

Auriol continued writing articles for various magazines and journals. Ironically, one such article, in the *Revue Encyclopédique*, talked about the Chat Noir theater, after he had already left the journal. The article was quite positive, showed pictures of the shadow theater operation, Henri Rivière working in his studio, and a program designed by Auriol. An editor's note in the article mentions some of Auriol's contributions to the Chat Noir.

On the personal side, events were not as rewarding. Auriol's relationship with Allais was diminishing, due to Auriol's work requirements, but also to their different artistic directions. Rivière had married and was spending less time with Auriol, although they still remained close friends. In addition, Auriol's father, at age 54, became sick and the prognosis was not good. While this must have had a profound effect on Auriol's mother and younger brother (who was still a minor), its effect on Auriol himself is unknown. Auriol did not appear to be close to his father, nor did he speak of him.

If anything, the events of the year and the effects of his personal relationships seem to have pushed Auriol into even greater artistic output. His recent artistic successes contributed a good deal to Auriol's sense of accomplishment, self-image, and security, but he felt

the teaching of Rivière. However, the floral and female images created by Auriol already show the emergence of his particular style, although not yet with a firm hand.

Roger Marx, reviewing the show, noticed Auriol's talent for decoration. "I was struck by the covers of Auriol . . . an instinct for decoration, a taste for flowers. The iris a subject of many examples . . . the flowers are full of life, sweet inflections, the throbbing of the stems, their balance of color."

Auriol's involvement in this show not only gave him a good deal of personal gratification, but it also gave impetus to expand his artistic

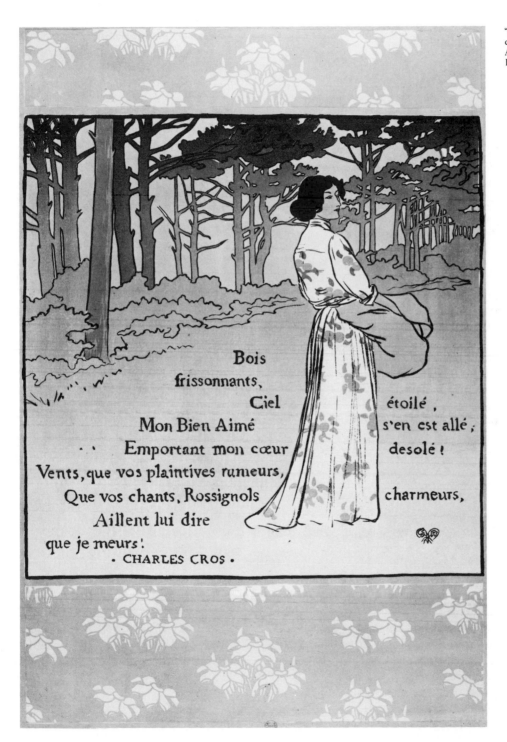

"Bois frissonnants,"
color lithograph by
Auriol, published by
L'Estampe Originale

Bois
frissonnants,
Ciel étoilé,
Mon Bien Aimé s'en est allé;
Emportant mon cœur desolé!
Vents, que vos plaintives rumeurs,
Que vos chants, Rossignols charmeurs,
Aillent lui dire
que je meurs!
· CHARLES CROS ·

Hachette et Cie

fluctuate, as his son described it, "from a child-like carefree attitude to a strong anger." Auriol made little time for social personal interactions. Only with Rivière did he occasionally relax.

The work Auriol did during this time helped to mature his artistic abilities and sharpen his style. His compositions grew stronger and more assured, his lines developing from sketchy to firm, simple, and clear. His images continued to be females and nature. The females appeared sometimes in groups now, but they still reflect an idealized vision, almost Grecian in dress and posture. The pictures themselves included more decorative items, but they were subtly integrated into the composition.

Natural scenes, trees, landscapes, and especially flowers were depicted over and over again, especially in Auriol's covers, menus, and program designs. Flat planes were used, the detail was often asymmetrical, but it reflected an elegant and refined use of line. Auriol's colors were mainly pastel shades, with emphasis on green, pink, orange, grey, and white. Young children now appeared in Auriol's work, more often just their heads and upper torso. The children were Semitic in looks, even more striking when done in profile, adding to an idealized feeling.

At this time, Auriol was asked by Larousse to decorate the cover and interior of the *Revue Encyclopédique*, the beginning of a long-time relationship with the publishing house. Larousse was apparently quite pleased with the work Auriol did for them, and they asked him to continue to decorate their monthly magazine. The *Revue Encyclopédique* cover had been a rather bland one, usually all in type with simple borders. Other magazines, however, taking advantage of the recent interest in illustrated covers, had turned to this new form. Auriol had already contributed to some of them. With Auriol's approach, the monthly looked much less imposing. The titles were surrounded by

the need to do even more, and better. Where one or two trips to a printer had usually sufficed to monitor progress on a commission, now he made daily trips. Relations with coworkers were often strained, and his outbursts did not help the situation.

Work, output, and production were uppermost in Auriol's priorities. A compulsive need to check and recheck turned even small assignments into large confrontations. When he did his own work completely, it was all right; when he relied on others to complete a task, from printer to typesetter to publisher, Auriol would

borders with leaves and fruit. Pictures some-
times appeared. The type for the titles was also
done by Auriol, always hand lettered. No type
available at that time could duplicate Auriol's
style.

The year also brought more commissions.
The publishers for *l'Estampe Originale* asked
Auriol to prepare the preface for their new edi-
tion. He made a woodcut, in color. Consistent
with his recent work, the image was a floral de-
sign. He also completed a book cover design
for Sarrazin. He had apparently done programs,
cards, and monograms for Sarrazin before.
This book cover, however, was a lithograph in
color. The book was *Les farces de Mijoulet*.

More color lithograph editions were
created, though no one knows who or what they
were done for. Their edition sizes are unknown,
but if Auriol was responsible for their publica-
tion, the edition sizes would have been 100,

Librairie Larousse

with a number of proofs. These lithographs
contained four to six colors. They were most
likely printed by Verneau, with whom Auriol
was currently working.

Auriol was developing his lithographic
technique well beyond that of his teacher,
Rivière. Rivière, at the time, was still doing
woodcuts and creating for the shadow theater
at the Chat Noir. It would be two more years
before Rivière turned more of his attention to
lithographs.

The progress that Auriol made in color
lithography and its application to book cover

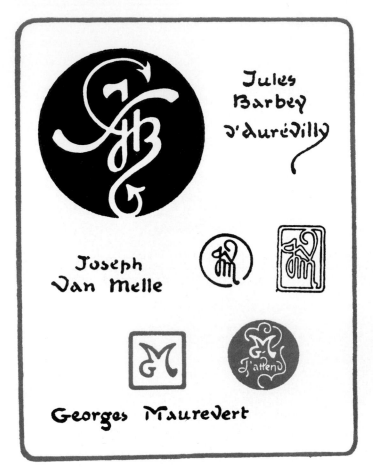

design demonstrated his fast maturing style. No longer a sketchy image, no longer resembling a Rivière-style composition, Auriol's work now made his own artistic statement. Lithography gave him the flexibility he required to experiment with design, layout, and color.

Auriol continued to honor his friends' requests for monograms, menus, programs, and posters. Another book was published by Flammarion, *En revenant de Pontoise*.

Early in 1894 Auriol's father died at the family home in Villiers-Cotterêts. Auriol was 31; his brother, Maurice, however, was still classified as a minor at age 20. Because he had

worked for the government for more than thirty years, Jean-Georges Huyot was able to leave a pension for his widow. This event seems to have had little effect on Auriol's productivity.

During the latter half of 1894 and into 1895, the Art Nouveau movement made itself evident in Parisian art circles. Further, the almost immediate publicity it achieved also made it very popular with the general audience. Many writers and art critics of the time—and through to the early 1900s—had identified Auriol as a participant in the Art Nouveau movement. However, the data shows, and Auriol himself strongly denied, any participation in it. In fact, Auriol became very angry with anyone who identified him as an Art Nouveau artist. Furthermore, he disliked Art Nouveau and whenever he could, he derided it.

The Art Nouveau movement was essentially a European style of decoration which began around 1890 and lasted into the early 1900s, although it was used commercially until about 1910. In each country it had its national variants. In France, however, the movement became most firmly established and lasted the longest. In France, Emile Galle and Louis Majorelle, who worked primarily in furniture and glass, were its leading exponents. Located in Nancy, their emphasis was on three-dimensional art objects.

In Paris, the emphasis was more on two-dimensional art and led to the development of the movement into posters and lithographs. Grasset, a friend of the Chat Noir artists and a well-known designer in Paris, worked in a similar style long before Art Nouveau was so identified. He too, however, was often labeled an Art Nouveau artist.

The new style got its first exposure at the Paris Exposition of 1889. At the Salon de Champs de Mars, in 1891, examples of the style were exhibited next to the paintings. In 1892, the writer and critic Octave Uzanne started a periodical called *L'Art et l'Idee* in which

A color lithograph, designed by Auriol, for a group of his friends

the new style was given a prominent position. But it wasn't until 1895 that the movement became popularized. One of its major contributors was Sigfried Bing, a shrewd businessman and art patron who had the knack of knowing what was new, what would attract and sell. He had developed a reputation for his promotion of Japanese art and Japonisme in Paris. In his shop, he featured the new style in painting and

applied art. He gave shows and received a good deal of press coverage. But more importantly, the sign hanging over his shop said "l'Art Nouveau." It quickly became the name of the new style.

The other major contributor to Art Nouveau in Paris was a previously undistinguished Czech artist, Alphonse Mucha. He came to Paris to study art, and, in 1894, was getting odd jobs doing illustrations in the academic tradition. By chance, he was working in a print shop that was commissioned to do a poster for Sarah Bernhardt, who was to perform a new show in Paris that season. The original artist's work was rejected by Bernhardt, and she demanded a new one be made immediately. Mucha was offered the assignment and produced a poster in a completely radical design for the period–"Gismonde." It was not only accepted by the actress but strongly promoted by her. It brought instant fame to Mucha–and more posters for Bernhardt. Within a short period of time, Mucha became *the* Art Nouveau artist.

Two other Parisian artists also contributed to the popularity of the movement. George de Feure initially used the style in furniture and iron work but devoted more of his attention to lithography and posters. Maurice Verneuil not only created many designs and decorations but wrote extensively about them in numerous books and periodicals.

The Art Nouveau style emphasized the ornamental value of line, the line of movement and rhythmic force, and a contour movement filled with tension. Asymmetrical in nature, it featured flat surfaces and a distribution of masses. In two-dimensional decorations (like posters, prints, and books), the lines were dominant, the contours soft and clear with a sense of balance between ornament and surface. The ornaments tended to fuse with the structure of the objects. Elements of the design seemed to flow into one another. The colors used were

usually pastel shades—green, grey, pink and white. In France, the emphasis was on floral and plant styles.

Auriol had been doing floral and plant designs, usually on flat planes and asymmetrical, since he did the Chat Noir theater programs. As he expanded into lithographs and book covers, he used pastel colors. Much of his work in the early 1890s consisted of decoration and ornamentation. Thus, Auriol was easily identified with Art Nouveau. Paradoxically, he talked against it; on the other hand, his work got him more exposure and jobs.

Junk is the only thing appreciated here. No one appreciates sturdy, simple, and well-balanced things. Ugly things do not bother any more. One has to be a believer to act as a decorator. One has to admire nature with all one's might, constantly studying it, and gather one by one, as treasures, the wonderful advice that she is so lavishly full of. One also has to love his craft with passion. One has to be fond of materials and know them thoroughly, know why they are beautiful and not want to modify them. It is a mania very much French which consists of imitating something—that tapestries imitate paintings, engraving looks like ceramics, stained glass windows look like frescos. . . . It is wrong to imagine that one can create a shape of a vase or conceive a design for furniture while drinking his hot chocolate. . . . In France, only a small group of artists understand the art of objects. But it is very likely that this group will not triumph over the national bad taste . . . they do not want to hear about it . . . and only a miracle will change them.

Although Auriol disliked the connection, identification with the Art Nouveau movement probably enhanced his relationship with Larousse and persuaded them to develop more

decorative book cover designs. It very likely helped in getting the job from Enoch to illustrate sheet music covers, and it probably was influential in attracting the Peignot foundry to use his talents. Peignot had previously used the talents of Grasset in the development of typography and they were interested in further innovations.

Productive
Years

N spite of increasing recognition of Auriol and his work, he still felt the need for exaggerating his behavior. When he accosted strangers on the street to prove a point and argued over insignificant details or comments, his friends, valuing his creativity, bailed him out. He was no less volatile in his approach to his work. Literally attacking the paper with pencil or brush, he would sketch furiously, lavishing his design upon the paper spontaneously. His next step was to refine the design more carefully and fill in the detail. Then, almost compulsively, he outlined figures or added flowery borders, a feature very uniquely Auriol's.

As he came more and more into demand, he produced more and more. By 1895 he had gained considerable public exposure. His third book, *Contez-nous ça*, was published by Flammarion and helped establish him as a reputable writer of humorous stories. When a book portraying a shadow theater production by Rivière was planned, Auriol was asked to create the titles and interior design. The book, *L'enfant Prodique*, contained colored lithographs by Rivière and the music of George Fragerolle,

and was also published by Flammarion and Enoch. This was Auriol's first working assignment with Enoch and began a relationship that lasted more than thirty years. It also led to more design assignments from Flammarion for illustrated music books.

As an example of the esteem Auriol received for his humorous books, he was asked to participate in a collaboration with other leading writers that Flammarion published in the magazine *Gil Blas*. "X" was the main character in the story. A chapter about "X" was written by each author. "X" could not die, and the author of the succeeding chapter must resolve the complications in which "X" got involved in the preceding chapter. Other authors sharing this assignment were Tristan Bernard, Georges Courteline, Jules Renard, Pierre Veber. The stories were well received.

Auriol returned to military service for twenty-eight days in March with the 39th infantry regiment located in Paris, and finished out his active military duty. He was put in the reserve in 1897 and discharged from service in 1909. Apparently he did little during this period because he referred to himself as a "library soldier."

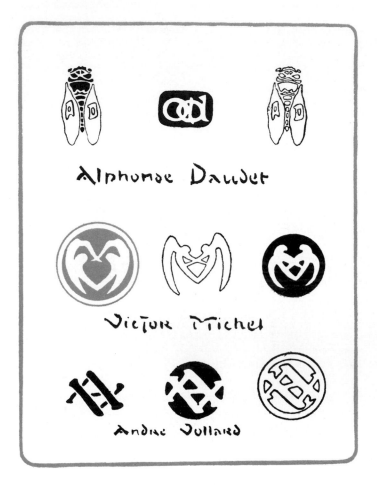

More book cover design assignments awaited Auriol. One was a book of songs, *Chanson Naïves;* another, *Contes pour les bibliophiles,* a group of stories by Octave Uzanne and Albert Robida. Sarrazin published *Chanson d'Hiver,* but this time Willette did the cover and Auriol did drawings for it. Auriol also prepared a number of lithograph editions in color during 1895. These editions, as well as some of his previous work, were featured in two shows, the Centenaire de la Lithographie exposition and the Société Nationale des Beaux-Arts exposition. The fact that he was invited to both

of these shows demonstrated the reputation he was achieving.

In 1896 and 1897, two more books Auriol had written were published by Flammarion, *Hanneton Vole* and *Le Chapeau sur l'Oreille.* Also in 1896, Vollard published a color lithograph of Auriol's in his *Album des Peintres-Graveurs.* It was called "Jeune femme assise," in an edition of 100 numbered pieces (plus additional proof sheets). Again, the lithograph pictures a young woman, dressed in a flowing gown, sitting before an open window. The design has a strong Japanese style, enhanced at the top and bottom of the picture with a repetitive floral motif.

Through this productive (and publicly recognized) period, Auriol seemed to form no close friendships or associations except with Rivière. We know from Rivière that they ate together often and frequently made the rounds of shops featuring Oriental art and artifacts. Other associations appear to be primarily work-related. Auriol was continually on the go; "in transit," a critic mentioned. He was obviously doing many assignments at one time. As his self-worth increased, as he became "bigger" in the eyes of his following, the more he drove himself to work, an indication of a strong interrelationship between his productivity and the need to feed his ego.

The events and accomplishments of 1897 continued to fuel his personal performance, but a number of things occurred that altered his artistic directions and more intimate relations. In January, Auriol was asked to do the cover designs for *l'Image,* a journal on the use of woodcuts in books. The editor was Bouyer, who wrote about Auriol as an Art Nouveau artist. The assignments did not last very long. Auriol and Bouyer probably didn't get along.

In March, the people responsible for the annual Durand-Ruel show, Société a Peintres-Graveurs, commissioned Auriol to do their catalog covers. Auriol also completed a book

Color lithograph book cover by Auriol

cover for *Le Thyrse,* a book published in Brussels, Belgium, his first outside of France.

Another book cover done by Auriol at this time, *La Belle d'Aôut,* by Auguste Marin, shows a peasant woman carrying a large water jug, walking down a path in a wooded area. The trees are somewhat stylized but the figure is realistic. The environment portrayed is calm and tranquil. The most interesting feature about this book cover is the excellent color and line printing—the best lithograph book cover done to date by Auriol. A major breakthrough in color rendition of book covers had been

achieved. In addition, a continuation of the front cover design appeared on the back cover.

Vollard asked Auriol to create another color lithograph for his *Album des Peintres-Graveurs.* This piece, called "Tête d'enfant" was Auriol's first imiage of a young girl, one of the first pictures he created portraying a person in conventional dress and fashion. The girl who served as a model for this piece was used by Auriol a number of times for she appears in other lithographs. Her manner of dress and hair style were identical in the succeeding pictures, suggesting that Auriol used the sketches from one sit-

ting for a number of images. The images he created in this series suggest a more relaxed, leisurely, and contented artist. This same change in the portrayal of women appears in his other work during this period.

For a book of Christmas music by Fragerolle, published by Flammarion and Enoch, Auriol did the cover, titles, and interior ornamentation. The cover showed a young woman, seated, dressed warmly, holding an infant protected by a thatched roof covering. Two women are standing nearby, apparently looking at a sheet of music. The scene is quite realistic, and the women resemble the peasants of Brittany. The picture conveys a relaxed situation, a feeling of closeness between the mother and child.

What might have precipitated this dramatic change in subject matter and emotional tone in Auriol's work? Women still appear in his pictures, but they now tend to be more real rather than idealized. Their demeanor, fashions, and behavior are real. Children are now present. The colors used are sharper and more opaque, the lines more definitive. Nature scenes are now portrayed. In fact, the existence of nature scenes has increased in the last few years.

Two factors may have contributed to this perceptual and emotional change. First, Auriol's need for recognition, prestige, and personal gratification had been met. Not only had people sought out Auriol to do work for them, but a number of them – Durand-Ruel, Vollard, and Enoch – returned to him, seeking more of his time and creativity. In addition, his inclusion in art expositions demonstrated the art critics' interest in his art. Further, he had achieved recognition outside of Paris, not only for the book designs he created, but participation in an exposition in Brussels, together with Chéret, Steinlen, Rivière, and Puvis de Chavannes.

The second factor was more personal. Georges Docquois, a writer colleague of Auriol's who had worked with him at the Chat Noir and with whom he kept in contact, introduced his younger sister to Auriol. She had come from Boulogne-sur-Mer, the family home, to visit her brother in Paris. Jeanne Augustine Margarite Docquois was 22 years old. She, like all other young women in her social class, had no occupation and lived at home. Her father was a professor of music and a highly esteemed person in the local community. Both her parents were quite old, her father 69, her mother 57. She was a formal, proper, and socially conscious woman.

Jeanne's family may have been concerned that she was not already married, as was the custom of the day. Going to Paris might have been a way to acquaint her with a wider circle of eligible men. Georges Docquois was quite familiar with Auriol, and knew about his personal life, and he may have arranged the meeting to promote the relationship. Auriol represented a good prospective husband for his sister—he was a successful writer and artist, a highly educated person, familiar with music, a hard worker, and a potentially good provider. Since Auriol was already 34 years old, he might very well be ready for marriage. Obviously, the meeting was positive and a relationship developed. But since Jeanne Docquois lived a distance away, their meetings were infrequent.

The two of them together made an interesting couple. Jeanne Docquois was taller than Auriol, and generally a thin woman. Along with her more formal bearing, she was rather quiet, and dressed severely. In contrast, Auriol dressed in a casual manner and was talkative. However, Auriol tended to defer to her, was somewhat in awe of her, and was more subdued in her company than he was away from her.

Auriol was deeply affected by the relationship. He appeared happier, less tense, and less argumentative. His creativity and productivity remained high. He seemed to be more interested in making continuous and stable business arrangements, and the "look" of his artistic endeavors took on new dimensions.

Auriol had perceived in Jeanne someone who would take care of his needs, support and nurture him, and give him a sense of security he had not had since coming to Paris. The anticipation that she would be a supportive force in his life helped to reduce the tension and anxiety he had built up over the years. His relaxed attitude became apparent in his relationships with people and in his art.

The events of 1898 affected Auriol's life for years to come. Along with his marriage,

Georges Bonnamour

Auriol's business alliances gave him a steady, comfortable income and his artistic choices opened new areas to explore and expand. For the sixth year in a row, Auriol had a book published, *Ma Chemise Brule,* like the previous ones, humorous stories. He continued his association with Larousse, decorating their monthly magazine. But they also began discussing with him the possible decoration of their larger volumes.

Auriol, Rivière, and Verneau, began in 1898 to collaborate on a project that lasted twenty years. Rivière created a colored lithograph each year, portraying a scene in Brittany.

For a part of the edition, Auriol designed and decorated a yearly calendar. Verneau's shop printed and distributed the edition. Through all national and personal problems—deaths, wars, changes in styles—the project was completed every year to 1917.

Of even greater significance, however, was Auriol's association with Enoch, the music publisher. Auriol had known Enoch and done work for them a number of times, usually books containing lithographs and music in which Auriol did the titles and decorative work. With the increasing use of color lithography in book covers, Enoch was interested in having Auriol

Enoch, the music publisher, who commissioned Auriol to create new designs for music sheet covers

create cover designs for the sheet music they sold. The opportunity offered a great deal of potential income to Auriol. Not only would there be many yearly assignments, but the artistic flexibility they presented was a challenge. Auriol accepted the job. The relationship continued until 1929. Auriol completed at least three sheet music covers their first year, all lithographs. After 1915, photo plates were used, but Auriol still hand lettered the titles.

Along with the work for sheet music covers, Auriol also made color lithographs for two books, *Bucolique* by his friend Renard, and *Les Modes de Paris* by Octave Uzanne. Both were richly colored pictures, repeating the new image selection and tone Auriol had begun to use. The covers for *Bucolique*—the front and back, although separated, were continuous, similar to the Japanese woodcut style—showed a young peasant woman in a wooded, rural setting, looking at a goose. The back panel extended the wooded setting and showed a number of geese. The covers for *Les Modes de Paris* were different images, although both portrayed Parisian scenes. The front panel contained two women and a female child, finely dressed, in a park-like setting. The Eiffel Tower is in the background. The back panel shows three women, wearing the dress of the day, walking on a residential street. In all these pictures, the people appear real and the scenery natural.

At the same time, Auriol worked with Rivière on another shadow theater play, *La Marche a l'Etoile,* doing the titles and ornamentation. In 1898, Andre Mellerio, an art historian and editor of the journal *L'Estampe et l'Affiche,* wrote a classic review on color lithography, which he called a "phenomenon unique to [his] time." He discussed the development of the color revolution in printing and identified certain artists who had made, or were making, significant contributions in this art form. He placed Auriol among the top print artists of the period, with emphasis on decorative design.

Auriol is without doubt the French artist who is presently doing the most original and decorative work in typography. His decorations for the Revue Encyclopedique, *his cover for* l'Image, *published by Floury, and especially the one for* L'Estampe et l'Affiche *are extremely successful. Auriol has also tried color lithography. Like Rivière, he is fond of flat colors. He often outlines them and imprints them with a decorative aspect.*

At this time, a book by Octave Uzanne, *L'Art dans la Décoration Exterieure des Livres,* on the use of decoration in books, features Auriol for five different book cover designs.

During this hectic, creative, innovative, and productive period, Auriol continued to design monograms for friends and patrons. As part of his changing artistic feelings and perceptions, he decided to create a new monogram for himself. The wispy lined "beetle" logo was dropped (gradually, over the period of a year) and a new, bolder, solid lined, stylization of his initials replaced it. He used this latter monogram on all his work for the rest of his life.

George Auriol and Jeanne Docquois were married on October 26, 1898, at her family home in Boulogne-sur-Mer. Auriol's mother was present, the only person from his family. Many people from his wife's family, including all of the immediate family members, were in attendance. After the marriage, Auriol's wife moved in with him at 44, rue de Abbesses.

To end the year, Auriol received more compliments, this time from Maillart in an article in *Art et Décoration,* dealing with the design of menus and programs. Maillart talked of the "glorious birth" of Auriol in Montmartre, being a "master decorator" at the Chat Noir, a writer of humor, and an imaginative decorator.

As a gesture of friendship to friends and colleagues in 1898, Auriol prepared his first Christmas card, an original lithograph, to wish them "les meilleurs souhaits"–best wishes. Thereafter he created one every year for thirty-nine years, completing the last one just before his death. The people and settings on these cards reveal a good deal about the self-perceptions Auriol had at each point in time.

The new year, 1899, brought further acclaim for Auriol. Another book was published by Flammarion, *A la façon de Barbari,* the only book written by Auriol during the next five years. He continued making book decorations

Christmas card
designed by Auriol in
1900, a color
lithograph, sent out
each year to
colleagues and friends

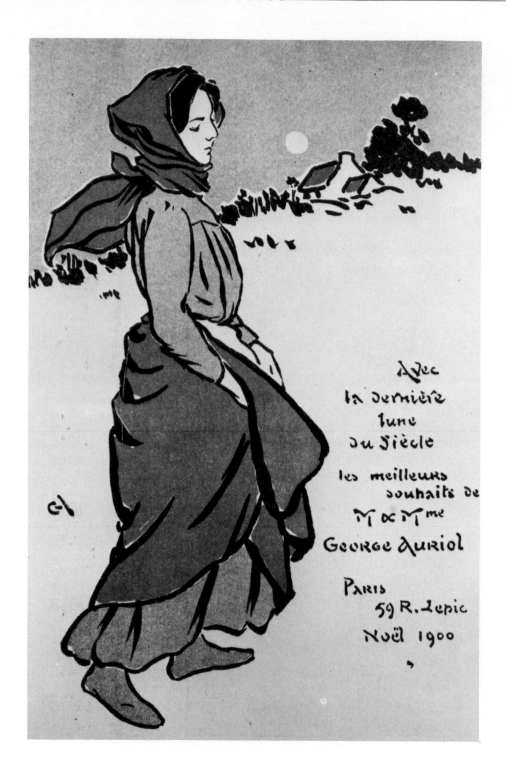

for Larousse and sheet music covers for Enoch. His titles and decorations appeared on Rivière's lithograph and calendar.

A long article about Auriol in *Art et Décoration* by Arsène Alexandre contained numerous pictures of Auriol's lithographs, woodcuts, programs, sheet music covers, monograms, and floral designs. Also included was an original color lithograph called "Schéhérazade," completed by Auriol a few years previous, but apparently never previously published. Alexandre quotes Jules Jouy in calling Auriol "His Grace of Nature." He identifies Auriol as a triple personality—"a writer, a painter and a craftsman." Auriol was

. . . a man who sees; and a man who sees is a man who understands; a man who understands is a man who creates; and a man who creates is the only one who leaves a trace among all the banality. He is a great admirer of nature. . . . it was his inspiration for creation. Unlike most other people, he knew how to observe nature and how to appreciate it. He is one of the rare artists who knew how to do so.

Discussing the Art Nouveau movement,

He was strongly opposed to the new freestyle — macaroni style — because he believed in tradition and using the teachings of the elders as a base, a foundation. . . . He believed in simple art . . . natural art created by man's hands, and believed that machinery in art was "Utopic." It is a distinctive trait of Auriol's character and talent to vigorously hate all which he finds of bad taste. He shows himself having a truly French temperament, loving above all clarity, simplicity, which do not go to exclude joy and the most splendid luxury — like an Utamaro woodcut.

Auriol could not condemn himself to only one media. . . . He needed a larger field of expertise. He went into decorating and tried his hand at ceramics. The book covers were the first application of his newly found talents as a decorator. While Auriol was becoming a decorator, he still remained an illustrator.

Auriol was often called the "Japanese of Paris," meaning that he brought to his work equal attention, equal pleasure in creating his line, equal joy to work on refinement. He loved, admired and understood Japanese art. However, he still remained a true French painter of popular pictures. He created his own style of modern typography, still using the letters as respected and loved symbols.

At the turn of the century, Auriol was perceived as a mature writer, artist, and designer. Within a few years, he had received a great deal of exposure, attention, and acclaim. His prodigious production and compulsive craftsmanship contributed to these achievements. He was acclaimed one of the top artists in Paris.

The Book
Business

HEN Auriol walked out the front door of the building he lived in, he found himself in the middle of a busy, noisy street typical of the neighborhood shops and stores found in Paris. Stretched out on both sides of the street in either direction for a number of blocks were the many small family-owned and operated stores and stands. Anything one needed was available—food, hardware, clothing, tobacco, household items—and on every corner, cafes and bistros. Between eight and twelve o'clock, the people purchased their needs for the day. And, while making these purchases, they talked to the shopkeepers and friends. Going out each morning was an important part of the daily life of the Parisian in 1900.

Paris was a vibrant city at the turn of the century. It had regained its claim as the cultural capital of western Europe. It was also perceived as the center of art. To demonstrate its international appeal, the final touches were being made for the World's Fair, at which industrial, commercial, and artistic examples from many countries would be on display.

The art scene in Paris was no less dynamic. Changes were being made rapidly in 1900—trends and movements of the previous decade were declining, new ones were claiming the attention of an art public that had expanded in size dramatically due to the proliferation and sale of graphics. More art dealers, more ateliers, and more artists flocked to the city than ever before. If the aspiring artist wanted to find direction and inspiration, Paris was the place to go. If the art enthusiast wanted to "discover" new art and new artists, Paris offered both.

One important movement of the previous ten years, the development of a serious and sophisticated print market, was declining for a number of reasons. First, the number of prints saturated the market beyond what it could adequately absorb; second, many print artists (and printers) had shifted their output more toward commercial and advertising opportunities; third, other artists just stopped making prints and moved to other media; fourth, many magazines and journals promoting the print market ceased publication.

Art Nouveau declined as fast as it had grown, mainly because of its emphasis on commercial application. The interest of the artist and the public shifted instead to original work—painting and drawing instead of prints. The Impressionists were being discovered as serious, creative artists with innovative styles. The emphasis on "reality" was waning, and representative colors gave way to an altered palette.

Sheet Music cover
designed by Auriol for
Enoch

Younger artists, many coming from outside Paris, brought fresh perceptions of styles and art forms with them.

These changes were noticed not only in the world of paint and canvas, but in the world of book design and printing as well. In a little over a decade the book had taken on added dimensions. Its looks and appearance were as expressive as its text. Color lithography on book covers and jackets made them works of art; interior design and ornamentation enhanced the visual experience of the reader; and innovations in typography added distinction and uniqueness to the printing and publishing worlds.

Prior to 1875, book design in France had been quite utilitarian. Bindings were usually two stiff cardboard pieces, sometimes covered with leather, used primarily to keep the printed pages together. Titles were often white or colored labels attached to the front and sides of the book. Only the most exclusive, limited editions were hand sewn, manually pieced together, and decorated with beautiful end papers.

During the third quarter of the nineteenth century, book design became a creative triumph. The invention of photography quickly led to its use in reproductive printing. Firmin Gillot invented the gillotage, making it much easier to prepare type for printing. Chemical engraving was applied to images appearing in magazines and journals and its application in books was readily accepted. Gillotage or zincographie, engraving or etching on zinc plates, represented a breakthrough in the ability to reproduce images in large editions. Octave Uzanne, a well-known Parisian art historian and critic, wrote, "More has been invented in the last 20 years than had been done from 1789 to 1860."

One of the most unique and successful developments was the use of colored illustrations both on the front cover of the book and within

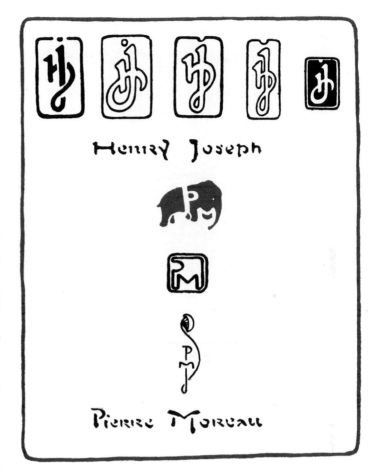

its text. The costs to produce this were less, the size of the edition could be increased, and more customers were attracted to them. Of even greater significance, however, was the fact that artists began to work along with the craftsmen and printers.

From 1880 to 1885, the book business grew dramatically. Existing publishers switched to color reproduction in their volumes; many new publishing companies were formed solely to produce color editions. Such publishers as Laurens, Quantin, Firmin-Didot, Flammarion, and Plon flourished. Some of the first covers

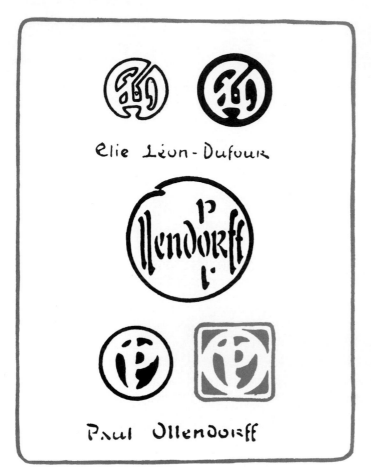

were those created by Vierge, Rops, Heidbrink, Vallotton, Robida, and de Feure.

The processes available to produce the books tended to obscure the great talent, care, and craftsmanship devoted to each edition, and also overlooked the unique working relationship that developed between the artists and their publishing colleagues. At the same time, we should not ignore the fact that this cooperation represented a significant showcase, as well as financial return, for the artist's creativity.

Auriol made significant contributions to these changes. Within a few years of his introduction to drawing, he prepared his first

book cover (1887). It was a simple line drawing titled in plain block letters and hand colored. But the design and layout revealed his potential talent. By 1890, he was being commissioned by Flammarion, Enoch, and Olendorf to design such covers. These covers showed a talent for lettering and design as well as image. By 1895, his lettering and ornamentation were being used by Vollard and magazine publishers. In a short time his color lithographic book covers and lettering methods opened new approaches to publishers.

In a few years, Auriol stimulated the whole creativity for book design and typography. He became the primary book artist of the period.

Like the Paris around him, Auriol in 1900 was a busy man. He had obtained a good deal of public exposure, thanks to articles like those written by Alexandre and Maillart. His designs appeared in Larousse publications and Enoch sheet music covers. Characteristic Auriol images also appeared on posters, menus, magazine covers; in addition, many people sought him out for personal (and business) monograms.

Auriol involved himself in all these assignments personally. After doing the daily shopping on his street, he rushed from publisher to printer to discuss and oversee every endeavor, no small feat as these locations were distant from one another and from Montmartre. Shorter distances could be reached on foot; those on the other side of town (like Verneau's studio) were reached by omnibus. In any case, Auriol spent his day on the go. When he arrived home, the remainder of his time was spent in his studio developing new designs, reading, and writing. He had little time (or inclination) for much social activity. His desire for production remained high.

Another book of Auriol's was published by Flammarion in 1900, *La Charrue avant les boeufs*, but it had been written the year before. He had no time now for writing books, and did

Sheet Music cover
designed by Auriol for
Enoch

not undertake another one for five years.

Auriol's frenetic activity and success coincided with that of the Larousse publishing house. Larousse had become one of the top publishers in France, although they had been in existence only a relatively short time, for French publishing circles.

Pierre Larousse had formed his company in 1849 when he published a *Grammaire Lexicologique*, a book on new methods of teaching grammar in the primary school levels. The success of this book led to others in the educational field. In 1866, Larousse began work on a monumental exposition, *Grand Dictionnaire*

Universel du XXᵉ Siecle (in 17 volumes). While it was not completed until 1888, many years after Pierre Larousse died, it established the publishing company as the authority on encyclopedic reportage. In 1891, Larousse put out a monthly journal *Revue Encyclopedique,* founded by Georges Moreau, devoted to detailed reviews of history, art, and literature. It was with this journal that Auriol began his affiliation with the publishing house.

In 1894, Larousse asked Auriol to design and ornament their journal covers. This soon led to lettering and ornamentation in the interior of the journal as well. By the turn of the century, Larousse became interested in publishing encyclopedic editions, primarily permanent, finely designed books. Auriol was commissioned to begin developing the covers, title pages, and internal ornamentation for these proposed books. His first production came out in 1905, *Les Sports Modernes Illustrés.*

The second book, *Le Musee d'Art,* appeared in 1906, its cover in embossed leather. It was followed by books on Spain, Portugal, Belgium, and Japan, a medical dictionary, a commercial encyclopedia, and a nature series. In all, at least twelve books using Auriol designs for the cover and the interior were published by 1915.

Similarly, Auriol and Enoch were collaborators on original art and design for sheet music covers. Each Auriol picture was a unique lithography edition in itself. He did seven of these in 1900 alone. He did more than one hundred of them up to World War I. All of these earlier editions were done by Auriol by hand on lithographic stone.

Because of Auriol's earlier experience in doing the titles and ornamentation for books on the shadow theater productions, he was asked to do new ones by other publishers. Rivière was no longer involved in these productions, but other theaters continued the practice. A number of these books appeared during the early 1900s.

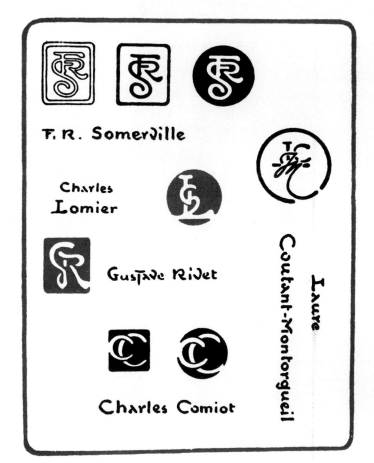

Auriol and Rivière still worked together on Rivière's yearly publication of a lithograph edition and calendar from the series *Le Beau Pays de Bretagne*. The calendar design was a challenge to Auriol because he had to include all the days of the year, special holidays, recognition of the artist and printer, and an advertising message. As was his style, all work was hand lithographed with Auriol's unique lettering styles.

In another collaboration with Rivière and Verneau, Auriol created the book design, embossed cover, box, and lettering for Rivière's book, *The 36 Views of the Eiffel Tower*, a limited edition published in 1902. Today it represents a beautiful and rare example of Auriol's creativity.

Further discussion of Auriol's work continued in art magazines during the early 1900s. Bouyer, a literary supporter of Art Nouveau—and attempting to identify Auriol with the Art Nouveau movement—wrote in *Art et Décoration* about his ornamental design and monograms. He cited Auriol as an artist who combined the art of Japan and the art of flowers in a modern French style.

Arsène Alexandre, reviewing the book *Chansons Atelier*, prepared by Delmet, in which Auriol designed the interior and included a color lithograph, imagined the studio of Auriol.

The studio of George Auriol is the open air, and the artist, a harmonious decorator, has his own original way of working there. Lying on his stomach, in the grass, looking at the forms of the flowers and at the games of the insects, or lying on his back, drawing on the blue stretches of the sky and the pretty designs of the plants, clusters of leaves, of petals, of stems, shells, butterflies . . . capturing this scene, putting it carefully in his pocket, to remake in the city pretty ornamentation.

Cover of the book of Art Nouveau designs by Verneuil,
Auriol and Mucha

Gustave Soulier, a well-respected art critic of the day, discussed the covers designed by Auriol, from the early work on *Revue Encyclopedique*, to Enoch and current examples. Soulier called him the foremost of designers. (*Art et Décoration*, 1901). Other similar articles appeared in 1901 and 1902.

During this time, one unique collaboration appeared that Auriol speaks nothing about, and it tends to throw doubt on his position on Art Nouveau. A very limited edition book was published by the Librairie Centrale des Beaux Arts (1901), featuring the ornamental designs of Verneuil, Auriol, and Mucha. The book consisted of separate sheets of paper, each with an ornamental design (or designs) by an artist — in color — as an example of the maturity of the style of the day. The book is very rare and is the only known collaboration of the best-known Parisian artists who were identified with the Art Nouveau movement. Why Auriol willingly participated in this book, as identified as it was with the "spaghetti" style of Art Nouveau, we don't know. Suffice it to say, the book itself is a significant example of the creativity of the participating artists.

Late in 1901 Auriol, now becoming well known and established as a book designer, was approached by George Peignot, head of a large foundry in Paris, with an interesting proposition.

Typography

HE Peignot foundry was one of the premier companies in France. It was established in 1868 by Gustave Peignot. His success in producing lead type for publishers led him to acquire the Longier foundry in 1881 and the Cochard and David foundry in 1892. By 1898, it was called G. Peignot and Sons, as Gustave had his five sons working in the company. A year later he died, and his son George took over as head of the foundry.

George Peignot was interested not only in heading up a company; he was also very interested in introducing new typography into the industry. For a number of decades, French typography had demonstrated little in the way of creativity. Both foundries and publishers appeared to be satisfied with duplicating the familiar forms. Peignot was looking for innovation. He wanted to reawaken the industry.

Peignot asked Grasset, who had made significant contributions to design, lithography, and the Art Nouveau movement, to design new typographical characters and ornamentation.

In 1899, the new "Grasset" type was introduced, and the printing and publishing market in France took notice. Response was positive and encouraging. After its appearance at the Universal Exposition in Paris in 1900, the new typography helped stimulate the industry.

When Auriol was approached by George Peignot, he was asked to create new typographical characters and ornamentation just as Grasset had done. Typical of Auriol, he attacked the assignment vigorously. In the space of two years, he produced three new type forms and hundreds of ornamental designs. "Française légère" appeared in 1902; "Auriol Labeur" in 1902, and "Robur" in 1903. "Française légère' was first seen in the book, *L'Orgie latine*, by Felicien Rops. "Auriol Labeur" was first seen in *A Rebours* by Huysmans. Response to Auriol's work was very positive, and many publishers used both the type and the ornamentation.

The period with Peignot was a fruitful one and established Auriol as an authority on typography. When Auriol developed his type characters, he worked "on site" with the foundry people. He prepared all of the letters and

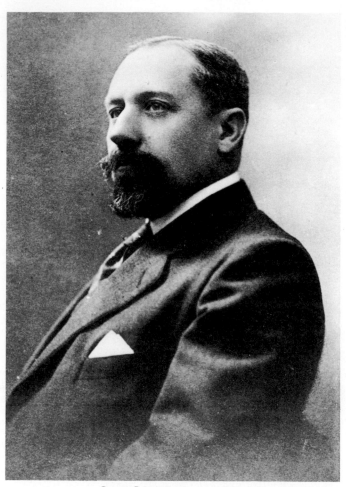

Georges Peignot sought out Auriol to invent new type styles and book ornamentation

In a book by Marty, *l'Imprimerie et les Procédés de gravure au XXᵉ siècle*, Auriol said,

The difficulty to blend and harmonize the character to an irregular drawing as well as bad taste drove me to draw letters which, after diverse transformations, became typographical. . . . I did not draw a particular type for engraving. I did not modify my letters so that they would meet the engraver's capability. I begged the engraver to engrave them as faithfully as possible, as my hand had formed them. . . . The engraved letter must keep the memory of the hand's work, the hand which drew it . . . one must preserve the aspect of a drawing instead of imprinting a geometrical shape.

During the latter part of the association between Peignot and Auriol, Peignot moved to new quarters. Auriol created the ceramic designs that Peignot placed in the walls of the building. Just a few years ago, when the old foundry was closed and the land sold to a developer, the building was torn down. Unfortunately, Auriol's ceramics were destroyed as well.

Unfortunately, the successful collaboration between Peignot and Auriol did not last very long because of a lawsuit. Auriol himself was not directly involved, but the episode seemed to affect his interest and involvement in typography. Renault, a small foundry in Paris, because they could not hire designers of their own, copied and sold the typography characters of other foundries. One of the characters they sold was very similar to Auriol's design. George Peignot, in order to prevent them from threatening his market, took Renault to court, claiming they were plagiarizing the type he had developed. In a surprise decision, the judges said that it was hard to prove that the type

ornamentation with a brush and ink, tracing the original designs on drawing paper so they could be duplicated by the type printers. He worked with them until the final product was satisfactory to him, a very difficult job because many of Auriol's designs could not be adequately transformed into lead type.

ABCDEFGHIJKLMN
OPQRSTUVXYZ
ÉÈÊ ÇWÆŒ &et etc.,'!
abcdefghijklmnopqrs
ſſuvxyz èàèùâêîôû çwœ
œ :;-()⦿""? 1234567890

L'Auriol.

AABCDEFGHIKJLL
MMNNOPQRRSTU
VXYZÉÈÊÇWÆŒ&

L'Auriol italique.

ABCDEFGHIJKLMNOPQ
RSTUVXYZ ÉÈÊ ÇWÆŒ

La Française allongée.

ABCDEFGHIJKLMNOPQRSTU
VXYZ ÉÈÊ ÇWÆŒ et etc..,;'-()⦿

La Française légère.

ABCDEFGHIJKLMN
OPQRSTUVXYZ ÉÈÊ
ÇWÆŒ ..;;'-()⦿*!?

L'Auriol Champlevé.

ABCDEFGHIJKLMN
OPQRSTUVXYZÉÈÊ
ÇWÆŒ &et „.::;'-⦿!?""
abcdefghijklmnopqrst
uvxyz èàêùâêîôû etc.
çwæœ fiflflffiffl
(1234567890)

Le Robur.

ABCDEFGHIJKLMNO
PQRSTUVXYZ ÉÈÊ &

Le Robur italique.

ABCDEFGHIJKLMNOPQRSTUVXYZ
ABCDEFGHIJKLMNOPQRSTUVXYZ

Le Robur allongé.

ABCDEFGHIJKLMN
OPQRSTUVXYZ

Le Clair de Lune.

ABCDEFGHIJKLMNOPQRSTU

Le Clair de Lune allongé.

93

Peignot was selling was itself original. If it couldn't be proven that the Peignot type was original, then it couldn't be proven that Renault was plagiarizing. The court said Renault could continue to use the type, and Peignot was ordered to pay the costs of the trial, decisions that angered Peignot.

Auriol did continue to develop some new type for Peignot during the next few years, but he concentrated more on differentiating them from the disputed type rather than on developing new characters. By 1905, the working relationship between Peignot and Auriol declined to the point where they decided to part. Peignot may have felt that the foundry had enough of Auriol typography (as happened with Grasset) and wanted to look for other artists to develop new characters. It is quite possible, also, that the Renault episode reduced Peignot's ability to market further Auriol creations.

Auriol's reputation as a designer of cachets and monograms had grown during the 1890s to a point where many well-known people were using his creations. In 1900, Auriol, along with publisher Henri Floury, decided to prepare a book that displayed the monograms produced for the literary and artistic people of the decade. Ultimately, three books were published. The first of these appeared in 1901. It was all hand lettered by Auriol, using brush and ink (except for the title page, which was type set), and Roger Marx wrote the preface. In it, he talks about the innovative design Auriol created. "One remains surprised at this extraordinary aptitude . . . to modify the structure of the letters and to get out of their similarities some unexpected variations. . . . They give the appearance of animals, stars, butterflies, moons, the phrygien hats."

The first book of monograms included those he created for his artistic friends: Rivière, Steinlen, Somm, Willette, and Verneau, but also Toulouse-Lautrec, Verlaine, Mallarme, Burty, Jouard, and Anatole France. In 1908, the second book of monograms was published, again all hand lettered by Auriol. This volume, besides the familiar monograms, also included ex libris designs, book marks, and company logos. It included such people as George Peignot, Andre Marty, Astruc, and Enoch, and also such companies as Peignot, Librairie Larousse, editors Laurens and Cadbury. Anatole France wrote the preface, extolling the talent and originality of Auriol.

George Auriol is not only a delightful story writer, a scribbler of new short stories, he is also a designer of letters, monograms and typographical ornaments. It was such that he was introduced to the art public by our very dear Roger Marx, so skillful and swift in discovering young talent. . . . This is the second book in which one will again encounter the same artistic ability to bestow upon letters an individual character, a lively expression, very often a shrub or flower-like look, and harmonize them together as the vine is harmonized with the young elm. . . . Auriol's charming ingenuity . . . rivals with the most famous ornamentalists and printing engravers . . . giving beauty and charm to books, brochures, menus, invitations. . . . If he so desires, the smallest tradesman can now give his labels character and style, thanks to George Auriol.

And this is not all yet . . . this ingenious Auriol created alphabets consisting of Roman, italics, big and small text, now being used by printers. Drawing a letter well and properly is no easy process. One knows how Leonardo da Vinci set about doing it in order to succeed!

Much rigor and precision is required in the drawing to create a feeling of independence and freedom. On such a small design nothing must be left to chance and yet the little design must appear simple and free. This is what all typographical drawing masters know and this is also what the delightful George Auriol knows as well as them, able to transmit to his alphabet a sense of decision, grace and originality from his mind.

Near the end of his involvement with Peignot, Auriol began to explore other possibilities. He worked with Rivière on making illustrations in a book for children, *Tableaux Intuitifs*, by Georges Moreau. It was part of an exposition dealing with "L'Art a l'Ecole." He also returned to writing after an absence of five years. Between 1905 and 1915, he published eight books, the first five published by his old friends at Flammarion. The first of these, *L'Hôtellerie du Temps perdu*, came out in 1905 and as before, were all humorous stories and supplemented his earnings as his work for Peignot dwindled.

During the first few years of Auriol's married life, he made the best income he had ever enjoyed, or would enjoy later. Auriol was a self-employed artist; he lived on the commissions and assignments he obtained. He was able to develop ongoing relationships with a number of people who maintained a relatively steady flow of work, sheet music covers for Enoch, book designs for Larousse, typography for Peignot.

He was available for magazine designs, posters, menus, and, of course, monograms. While they were irregular, the frequency of these commissions helped his cash flow. From 1898 to 1903, Auriol did quite well monetarily. His reputation as an artist/decorator was excellent; exposure of his name was high due to the numerous articles about him. His association with the Art Nouveau movement helped.

Birth of
a Son

ITHIN a year after their marriage, the Auriols moved to better quarters. Auriol had been living at 44, rue des Abbesses, since 1892 and the newly married Auriols remained there, as noted on their first Christmas card. But during the middle of 1899, they moved to 59, rue Lepic. While these new quarters were only a block away from the previous ones, the building was newer, had an entrance courtyard and small garden, and was much higher up the Montmartre "butte." Much more of Paris could be seen from its windows. They stayed in this apartment for over four years.

During 1903, however, the Auriols moved back to 44, rue des Abbesses. While it may have been coincidental that they returned to their former quarters, a reduction in Auriol's income may have precipitated it. It was just about this time that the Peignot-Renault court case occurred. Further, it appears that the frequency of commissions declined as well.

From the time he arrived in Paris until his marriage, Auriol never made much money, neither was he in great need of it, as were many of his colleagues. When he came to Paris he got a job with Flammarion and worked at the Chat Noir. His contacts with Ollendorf, Larousse, and Enoch generated many assignments. He made at least enough to live a casual, simple life.

Auriol did not really care about obtaining a lot of money. Nor was he interested in spending it on things to make his personal living more comfortable. His primary purchases were books, Oriental artifacts, and flowers. No matter what his financial circumstances were over the years, these feelings about money never changed. His wife, however, had other feelings

The Auriols' quarters at 44, rue de Abbesses where he and his wife lived on the fourth floor

The Auriols' quarters at 59, rue Lepic

about money, what one does with it, and how it might be displayed. After all, she had been raised in a family that was well known and respected in the community and was taught the social graces of her station.

Madame Auriol, as she was always referred to, was a pretty woman. She was taller than her husband and very thin. She was very formal and was considered "grand" in her demeanor. She was also a very traditional wife. One of her favorite pastimes was holding weekly tea parties with her women friends.

Jeanne Auriol had a strong influence over her husband. In many ways, she mothered him, not only fulfilling all of the daily duties, but also meeting his emotional needs as well. Their home gave Auriol a sense of security and escape from the outside world. It gave him a place tailored to his creative needs. Auriol's apartment was also his studio. Walls were lined with book shelves and books. When one room was filled, another room was prepared with shelves. Auriol did his work in one large room, writing, designing, drawing, his latest creations pinned to the walls or doors, wherever space allowed. The room may have looked disorganized to the occasional visitor, but Auriol knew exactly where everything was.

The Auriols did not socialize very much together. During the normal work day, Auriol talked to a lot of people, but rarely were any of these people met at any other time. Madame Auriol, on the other hand, conducted her weekend teas, and would have liked to socialize more.

Auriol remained a loner, much as he did in earlier years. Part of this was due to his difficulties in getting along with people; part was due to his intense involvement in his work. Alphonse Allais, an old friend from the Chat Noir days, had left Paris a number of years before. Salis had died; Verneau became sick and died in 1906. Rivière, a very close friend for many years, had a number of his own personal

problems, and the two of them rarely got together, except for business purposes. Auriol's close associations with Peignot, Enoch, and the Larousse people were primarily work related.

Once he got home after a day of visiting ateliers, printers, and publishing houses, Auriol hardly ever went out at night. He and his wife ate dinner early, Auriol then spent a few hours in his studio, then he retired early.

Auriol was an early riser, usually getting up at 5:00 a.m. He made his own breakfast, and he was often heard by others at this hour—fighting with the bread bin, kicking the chairs, yelling at various objects in the kitchen that happened to get in his way. Once he had eaten his breakfast, however, he calmed down, was amiable to others, and spent some time working on projects before leaving to do the daily shopping.

The Auriols traveled very little. During the first few years of their marriage, they took summer outings at a location close to Madame Auriol's family home. On the way back to Paris, they made a small detour and visited Auriol's mother at Villiers-Cotterêts. Later on, even these summer trips stopped. Other than these trips, the Auriols never left Paris.

Auriol rarely associated with his brother Maurice. Maurice worked for the post office in Villiers-Cotterêts. He had married a woman no one liked, including George. Even though Maurice died before his older brother, no evidence that Auriol participated in the funeral has been found.

The public world of Auriol was creative and frenetic. He worked with many people on many projects, often many at one time. He was recognized and well known to the artists and craftsmen of the period and the literary and artistic elite as well. He was perceived as a highly creative, innovative, productive person, contributing in various artistic disciplines with equal ability. He also was viewed as a volatile personality, hard to work with, sensitive and

argumentative, and highly emotional.

The private world of Auriol, however, was closed, well structured and controlled. He chose his associations on the basis of his level of acceptance, or where he performed well, or where he was needed or wanted. He believed that people should behave in certain ways of his own definition. When they did not, or deviated slightly from the prescribed behaviors of the situation, he became very upset. In work situations, he might leave the atelier; in social situations, he might go to sleep. He rarely used the telephone, partly because he could not see the person to whom he was talking. Sensitive

Jeanne Auriol's recognition came during the early part of 1906. Seven and a half years after the Auriols were married, at age 31, Madame Auriol became pregnant. Auriol was 43. The pregnancy was quite unexpected, but nevertheless influenced the Auriol household. A good deal of attention was paid to Madame Auriol by her relatives and family, as well as Auriol himself. All indications were that Auriol was very happy about the event.

On January 8, 1907, a baby boy was born to the Auriols. He was named Jean-George—the same name that Auriol had been given. A very intense relationship between father and son developed while Madame Auriol's presence again receded into the background. Jean-George was a healthy, well-cared-for baby, the focus of the household. When Auriol came home from his daily activities, he spent his time with his son. When he went out in the morning to shop, Jean-George went with him. Auriol read to his son incessantly, and let him see the projects he was working on. In many ways, Auriol took over much of the emotional relationship with the child normally given by the mother.

Without doubt, Auriol loved his son and was very proud of him. The relationship was fulfilling to Auriol. He tended to smother his son with attention, care, and love. His son became an extension of the child in himself, possibly to compensate for the minimal relations he had had with his father (and later with his brother).

During the early years of Jean-George's development, he was quite dependent on his father. Auriol talked to him, read to him, and taught him. Auriol monitored his son's school activities. To his father's delight, Jean-George was an excellent student. Auriol's feelings about his son are reflected in his yearly Christmas cards.

Each year, starting in 1898 just after his marriage and continuing until his death, Auriol

to his size, he refused to be photographed unless it was a closeup.

While Auriol was baptized a Catholic, he did not practice the religion. He attended the church at his marriage, and occasionally when special events or family get-togethers demanded it. In the latter cases, he attended solely to meet his wife's demands. For the first eight years of his married life, Auriol lived this self-imposed life-style. Whether his wife enjoyed this or not, we are not aware, because she remained in the background.

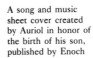

A song and music sheet cover created by Auriol in honor of the birth of his son, published by Enoch

in sequence, reveal Auriol's feelings over the years, particularly as we relate them to the events in his life.

From 1898 to 1906, Auriol's images are similar to those used in his bookcovers, posters, and menus—in some cases, he used the same images already used as illustrations in books: young females, in peasant dress, in rural areas, nature scenes. In 1907, the year of Jean-George's birth, the card portrayed a mother and a very young child in a gardenlike setting. Included in it was a small Teddy bear. This imagery continued in 1908 and 1909. But in the 1910 card, two young boys of equal age are pictured, playing together in a garden, apparently in a rural setting. This same pattern is repeated, the boys looking obviously older each year, until 1919. From 1915 to 1919, the boys are acting out "war" situations.

The evidence suggests that the two figures in the holiday greeting cards were Jean-George and his father, George, identifying himself as a child companion to his son. This perception is supported not only by comments about the relationship between the two, but by conclusions made previously about Auriol's behavior. George Docquois, the brother of Madame Auriol and himself a writer and friend of Auriol, dedicated a book to him calling him "the sweet good child he is."

In the 1920 card the children are omitted and a fantasy situation with elephants is included. The children never again appear in the cards. From 1921 to 1938 the images are similar to those made during the first few years of this ritual, rural scenes showing young peasant women laboring in the fields. It is summer with the sea and boats in the background. In no card, except those showing the children, were males ever shown. In the cards completed during the last five years of Auriol's life, the images remained the same, though they became sketchier and simpler, and fewer colors were used.

prepared a holiday greeting card to send to friends, relatives, and business associates. Each of these cards was an original color lithograph on heavy cardboard stock, usually about 5"x7" in size, carrying a holiday greeting, the date, the address, and the name—M. et Mme. George Auriol. These cards, when examined

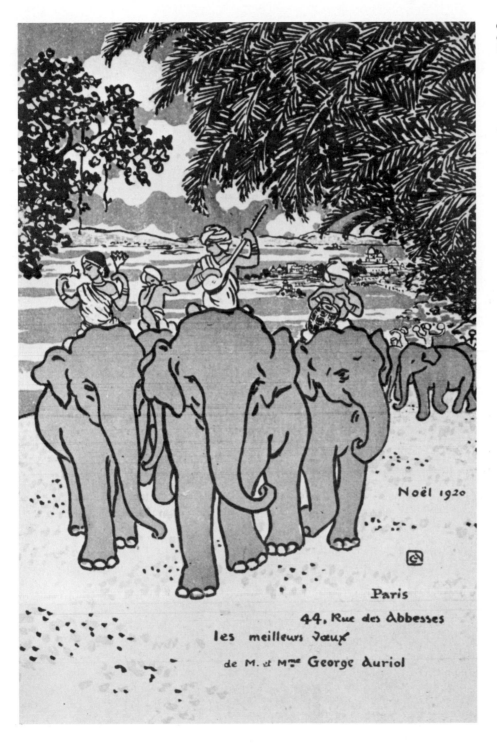

Christmas card
designed by Auriol in
1920

Christmas card
designed by Auriol in
1924

Noël 1937

les meilleurs souhaits
de M. et Mme
George Auriol

PARIS
44, Rue des Abbesses

The last Christmas
card designed by
Auriol in 1937, just a
short while before he
died

the war, were children's books, almost patriotic in nature, dedicated to his son. In both *La Geste Héroïque des petits soldats de bois et de plomb* and *Les Aventures du Capitaine Longoreille* another artist did the illustrations. As in previous years, Flammarion was the publisher.

Auriol continued drawing and lettering sheet music covers for Enoch. The images themselves had become more complex and intricate, and they were all still hand drawn by Auriol, using the brush, but the printing process was modernized for large editions and worldwide distribution. Auriol completed close to twenty-five designs during this period.

His activity with Larousse continued as well. Now, however, Auriol was designing the elegant encyclopedic editions with embossed leather covers, titles, ornamentation, and end papers for each. Auriol completed at least twelve books up to 1915. In addition, he was commissioned occasionally to do magazine covers, programs, and menus. Some evidence indicates that Auriol also prepared covers and brochures for commercial businesses in photography and dental aids.

During this period Auriol's name was rarely mentioned in the art and crafts journals of Paris. Art Nouveau had become very commercial and declined almost as fast as it had risen. Paris was aroused by the color "battles" of the Fauves and the beginnings of the Cubist movement and Expressionism. While interest in books remained high, interest in their production and artistic contributions had waned. In an article in *Art et Décoration* in 1910, dealing with the "Vignettistes" of many artists, Auriol's titles and ornamentation were illustrated. He was included with Chéret, Ibels, Lautrec, and Grasset as an innovator in this medium.

With regard to the technique of these special productions, which elevates decorative art, it is perhaps necessary to give the top place among

Auriol's creative and business activities from the birth of his son to World War I, not surprisingly, were considerably reduced. Except for his daily shopping trips and meetings with the Enoch and Larousse people on projects, Auriol was more likely to stay at home. For another person this amount of productivity might have been viewed as considerable; for Auriol, it had definitely slowed. Still, Auriol wrote seven books between 1908 and 1915; the last two, published during the early part of

professionals . . . to understand the harmony of ornamentation and the text, the ingenious arrangement of letters and the image, [to] the superior and sensitive George Auriol, grandfather of charming typography, with his spiritual imagination, his skillful stylization of plants and his picturesque characterizations.

A conference in Liege, Belgium, in 1911, on "l'Art et le Livre" reviewed the contributions of well-known book designers from England, Belgium, and France. Auriol was selected as one of the four best book designers in France and a published document featured five of his covers. In 1914, an article in *Studio* magazine, an art journal published in France and England since 1893, displayed book designs by Auriol along with English contributors. However, no text discussion of Auriol was included in the article.

With the war came the shutdown of any commercial activities by the French. This included Enoch and Larousse and most of the Parisian publishing houses. During the war, the Auriols remained in Paris. Auriol had very few assignments. He continued to write articles and short stories, some of which were published and some set aside for future publication. Jean-George went to school, and Auriol was continually involved in his son's activities. It was, nevertheless, a restless period for Auriol.

The end of World War I reignited the artistic scene in Paris almost immediately. Its production and display were manifested by the Dada and Surrealist movements and by the influences of Picasso, Braque, Leger, Duchamp and Dali. Book publishers, too, experienced a resurgence of interest. The people, starved for the written and illustrated word for a number of years, purchased everything that was made available to them. It took nearly four years after the war to build an inventory of available material.

Larousse and Enoch, like the other publishers, responded to the public's demands. Auriol was called upon to create and produce as he had before. He was ready to meet these needs and happy to reinstitute his busy daily life visiting ateliers, printers, and publishers.

The Last Twenty Years

 RANCE, in 1919, was converting its industry from war to peace as rapidly as it could.

Public demand for goods was great as people felt the need to reward themselves after the imposed wartime limitations and to "catch up" on the technological developments made. The building and automotive companies worked around the clock just to make available the items people sought. The world looked to France once again for fashion leadership. A significant communications explosion brought pictures and words to the populace—thanks to the availability of radio, cinema, and the easily manufactured printed word.

The art scene in Paris was equally affected by these needs, and took full advantage of it. The public clamored for art in all forms, from new art movements to a reawakening of the Renaissance artists, from fine arts graphics to colorful posters and calendars produced by the thousands, from elegant leather-bound, limited edition classics to paperbacks. The problem for the artist and craftsman was not creativity, but rather production. During the first few years after the war, available production facilities were so heavily scheduled that a sizable backlog of work built up. At the same time, demands for products were so high that the facilities were strained to meet them.

George Auriol was a willing and happy recipient of this post-war artistic boom. He had spent almost four years at home writing short pieces, doing a few monograms, and continuing his daily contacts with his business colleagues. But the inactivity of the period frustrated him a great deal. Because of the war, Larousse and Enoch had suspended their publishing operations. Many other companies so reduced their production that there was little to do. Even the ever-present art journals reduced their issues, and when they did publish, featured the art of foreign countries.

Enoch approached Auriol first, asking him to create designs for sheet music covers to be

published in 1919. The effects of the war influenced the nature of the music being published, reflecting feelings and attitudes about peace, the return of the soldiers, and the reworking of the land. Some pieces portrayed the culture of foreign countries—a new, more international view than that previously displayed by the French.

In keeping with this new emphasis, Auriol was asked to design covers that reflected the message of the music. This was a welcome challenge for Auriol because previous sheet music cover designs carried primarily flower, plant, or nature motifs. He saw this not only as a creative opportunity, but he used it to experiment and initiate new lettering as well. Rather than just a decorative adjunct to the music itself, the sheet music cover became an important selling device.

George Auriol about 1920

Auriol designed at least ten covers in 1919. And, typical of his working methods, he was involved in all aspects of the printing and production for each of these designs. His daily travels and encounters reawakened his artistic enthusiasm.

During the next few years, through 1922, Auriol completed more than thirty-five sheet music covers. Some utilized bright reds, greens, and blues contrasting with the previous use of more subdued colors. Some depicted fantasy scenes of cities and towns instead of rural scenes, and people were depicted more than before. The use of color with offset lithography enhanced the reproducibility of the images.

All the images Auriol created were hand drawn and colored with the brush, as he had always done. He worked closely with the engraver to transfer his work to the printing plates. Luckily, much of his lettering did not have to be prepared in lead before use because his lettering was so fragile as to make lead type impossible.

When Larousse began publication again, they asked Auriol to work with them to produce a series of encyclopedias on the histories of various countries, as well as a series on the natural sciences. In both cases, elegantly designed books similar to those they were doing before the war were planned. Auriol made the covers, the end papers, the titles, and the ornamentation. Similar to his recent assignments for Enoch, the images were closely related to the subject matter.

In addition, Larousse continued publishing educational texts. Auriol created the covers and ornamentation for some of these books. The designs Auriol prepared for the Larousse books, both exterior and interior, made extensive use of the flower, plant, and nature motifs similar to those done in his various productions twenty years earlier. For the book covers and title pages, they appeared to fit the need. The book covers were done in color-dyed leather,

Example of a book
cover designed by
Auriol for Larousse

deeply embossed with the image, the embossing itself creating highlights and shadows that enhanced the picture. The printing was in gold. The covers themselves were four centimeters thick. Auriol completed designs for ten of these books by the end of 1922.

During this period, he also created a few announcements for art journals, made monograms for some companies, and even did some designs for ceramic dishware. But in 1921 Auriol received honor and recognition from France's authorities in book design, typography, and publishing. Francis Thibaudeau pre-

pared a two-volume set, *La Lettre d'Imprimerie*, that became the definitive encyclopedia for the profession. The books were dedicated to Auriol, who was called the "French innovator of typographic writing."

As a stunning example of his recognition of Auriol's contribution, Thibaudeau used various styles of Auriol's type faces for each book section: "Française légère" for the preface, "l'Auriol labeur italique" for the introduction; "l'Auriol labeur romain" for the text, "Robur allongé" for the legends, "Robur" for the numbering, and "l'Auriol Champlevé" for the chapter titles. Included in these volumes were historical discussions about the development of letters and their production along with actual examples of work. Featured were original woodcuts by Pidoll, LePere, and Beltrand, two pages of monograms and ex libris designs by Auriol in gillotage, original lithographs by Steinlen, Rivière, and examples of Auriol's Christmas cards. Pictures of Auriol's embossed leather book covers by Larousse and eight examples of "papiers de gardes" by Auriol rounded out the book's tribute.

For this two-volume set, Auriol drew by hand all of the titles and ornamentation and worked with the Peignot foundry to prepare them for the actual printing. The book was considered a classic then; it remains a rare classic today.

No sooner was this book completed than Thibaudeau started working on another encyclopedia dealing with modern French typography. It was published in 1924 and quickly became the definitive text on the subject. Although the book was not dedicated to Auriol, but to Grasset and George Peignot, it again utilized the various Auriol types throughout. Included in the text were five pages of examples of Auriol's ornamentation, the designs for Auriol's birth announcements, and a twenty-step method detailing Auriol's preparatory drawings as they were translated into engraved plates for printing, the only known example of

how Auriol did his hand drawings for ultimate engraving and printing.

During this time Auriol renewed his acquaintance with another member of the Peignot family. Great misfortune hit the Peignot family during World War I when four out of the five brothers were killed, including Auriol's friend, George Peignot. Charles Peignot was now heading the company, and while he was courteous to Auriol, he was very busy with other matters. They talked at length about books, and Peignot said, "He was a dreamer; cheerful, friendly and pleasant; cultivated with his small size, his beard and his funny voice talking through mashed potatoes." Nothing ever came from this meeting as Peignot was more interested in new designers.

During 1922 and 1923, Auriol prepared the third volume of his books on monograms, following the same format as the previous two except that it displayed more examples of ex libris designs and company logos than before. Among the personal monograms shown were those for Clemenceau and Woodrow Wilson; however, no evidence suggests that they commissioned Auriol to prepare such a monogram. The book was published in 1924, and all of the titles and lettering were hand drawn by Auriol.

By the beginning of 1923, France was returning to a more normal commercial existence, and artistic needs declined. Demands for Auriol's talents and time decreased dramatically too. While he still designed sheet music covers for Enoch, very few were done after 1923. In fact, he did only fifteen covers over the next seven years. The last one was completed in 1929. Similarly, Larousse continued to give Auriol book design assignments, but fewer of them. Auriol did about seven or eight books for Larousse over the next six years; the last one was published in 1930.

A number of factors contributed to the decline of Auriol's artistic efforts. First, consumer demand diminished in the areas Auriol was most known for, and a transition from familiar to new artistic stylizations took place. Second, new artists and new art movements became established in France and were duplicated by the commercial and business people for their advertising and promotional use. Third, Auriol's old contacts (and employers) died or retired from their positions. In both the Larousse and Enoch organizations, new directors took over the companies and developed new plans for them. This included seeking out new artisans and craftsmen.

antoine Chiris
et Jeancard fils

Claudé

Vedado Tennis Club

But of even greater significance was the perception that Auriol had become old-fashioned, artistically "passe," and, in fact, an old man. In 1923 Auriol turned 60. Physically, his hair had thinned and greyed. The lines in his face had become pronounced. He had gained weight and was more obviously rotund. While he still exhibited flashes of the volatile and argumentative person, coupled with humor and warmth, Auriol was more subdued and more likely to internalize his emotions. He was still very talkative and drew attention to himself in any conversation, but the philosophical and cultural debates had given way to comments almost entirely related to books and the book styles of the day. Even the clothes he wore, including his familiar hat, were "old fashioned."

Auriol's family situation caused some strain as well. Jean-George was now over 17, attending college, making new friends, and having new experiences. This separation from the family, and particularly his father, was very difficult for Auriol. After seventeen years of directing and supervising his son's life, Auriol's influence was declining. A good deal of tension developed between father and son during this period. Jean-George continued to live at home and remain dependent on his family as he completed school. Auriol tried hard to maintain some influence over his son.

As stubborn as Auriol may have been with respect to his son, he was much more pragmatic about his professional life. When friends and colleagues asked Auriol about his past experiences at the Chat Noir, about his old friends, about the artistic development of his "early days," Auriol refused to talk about them, not because he was modest or did not want to be identified as an "elder statesman," but because he lived in the "here and now." He was mainly interested in his current activities and future challenges. And he approached his career in the same manner.

As Auriol advanced in age and his work load lightened, two other opportunities opened up for him. The Ecole Superieure Estienne—a school of applied arts to train students in book design and typography—was headed by Georges Lecomte. Lecomte knew Auriol personally because they had both worked with Thibaudeau a few years earlier. Aware of Auriol's knowledge and experience, Lecomte asked him to join the faculty as a lecturer on the history

The Ecole Superieure Estienne, where Auriol taught from 1924 until 1937

of lettering and typography. Of course, Auriol accepted. From 1924 until he died, Auriol taught at the school, one hour a week each Saturday, for which he was paid 50 francs. While Auriol spent a good deal of time researching and preparing his notes, practically nothing remains in print of his lectures. Former students of his mentioned his "inspiring" and "moving" speeches, although none of them were aware of his background and accomplishments.

Because of his contacts with the book publishers and reviewers and his acknowledged writing ability, the editors of *A.B.C.* magazine, an artistic and literary monthly, asked Auriol to be their book reviewer. He read a great deal, visited book people, talked to them, pressed his opinions on others, and put his beliefs in print. He approached the job with his usual enthusiasm. He wrote articles for the magazine from 1926 until his death. Others considered him a most articulate but opinionated reviewer.

In December of 1926, Auriol's mother died at the age of 83 in Villiers-Cotterêts. A small funeral was held, Auriol and his brother Maurice attending. Madame Huyot was buried next to her husband in the town cemetery. Her estate, what there was of it, was divided equally between George and Maurice. During the ten years before her death, contact between Auriol and his mother had been almost nonexistent.

In 1929, Jean-George graduated from college as a journalist and obtained his first job with a magazine. Auriol was pleased with his son's choice of career. However, Jean-George

Jean-George Auriol

music covers for Enoch. For Larousse during the same period Auriol designed only two books. The working relationship with Enoch ended in 1929. Auriol's last cover was an image quite uncharacteristic of what he had previously done for Enoch, and the primary color was bright red. Auriol and Enoch continued communicating for a number of years, but primarily out of deference to Auriol being a former colleague. The last design Auriol did for Larousse, *Larousse Commercial Illustre,* for which he did the cover and the end papers, was published in 1930. He completed only three book designs for them in the previous three years.

The last book Auriol wrote, published in 1930, was about Steinlen. In 1917, Auriol had written a long essay on the life of Steinlen, particularly his activities at the Chat Noir and after, through his political commentary years into World War I. Steinlen died in 1923, but apparently few people, including the artistic people of the day, took notice of Steinlen's contributions. In 1928, Auriol was asked to expand on his essay and include material on Steinlen's achievements. The end result was the book *Steinlen et la vie,* and included many drawings by the artist. Auriol wrote the book in a conversational manner, as if he (and others) were conversing with Steinlen. Auriol's writing ability, his humor, his insight into the life of his colleagues of the time, were all well demonstrated. The book remains one of the best portrayals of the emotional milieu at the time these artists dominated the Parisian artistic scene.

Auriol's own emotional state and relationship with his son remained strained. One of Jean-George's close friends on their cinema magazine was Pierre Batcheff. Pierre had a younger sister, Sonia, whom he introduced to Jean-George. Sonia and Jean-George surprised many people when they announced their plans to marry in 1932, only a short time after the two had met. Apparently the reception after the ceremony was lively, because Auriol was

did not stay long at the magazine. He was very interested in the cinema and had immersed himself in it for a number of years. Along with some friends who shared this interest, Jean-George started a periodical called *La Revue du Cinéma.* Auriol was not happy with his son's aspirations, nor with his leaving his first job after such a short time and starting a new venture with little experience. Jean-George was still living at home, which did not ease their strained relationship.

The reduction in Auriol's usual frantic activity did not help his state of mind. Assignments with Enoch and Larousse declined. Between 1924 and 1927, Auriol did only six sheet

so offended by the participants getting drunk and using bad language that he wanted to leave.

The marriage itself was rather stormy and lasted only a few months. During this time the *La Revue du Cinéma* was terminated. However, a friend, associate, and well-known writer, Nino Frank, asked Jean-George to work with him on a cinema periodical to review American films. He took the job. Within a few years he became quite well known for his work and contributed greatly to the success of the magazine.

Little is known of the day-to-day relationship between Auriol and his son throughout these years, though they seem to have become close again. Auriol was proud of his son's progress and accomplishments; Jean-George was respectful and devoted to his father.

From 1932 through 1937, Auriol's life followed a routine. He arose very early, engaged in his usual confrontation with the kitchen, and, after breakfast, went shopping on the rue de Abbesses. Besides doing the necessary shopping, Auriol made the rounds of the book sellers and book shops, talking about and criticizing the books he had read.

His afternoons and evenings were spent reading (as voraciously as ever), writing his reviews, and preparing his weekly lectures. Often, during the day, he visited old friends and associates at the book publishing or printing companies. His primary topic was books; the people there had little choice but to listen. Publishers in Paris sent their new books to Auriol, not because he was a critic, but because he became a spokesperson for them.

Auriol made a similar impression on most of these publishing people. "He was a nice man, sociable, talkative; he talked books, books, books; a small man with a moustache and beard, always a hat on his head; he could be gay and cheerful—he could be mad and furious."

Social activities in the Auriol home were infrequent. Occasionally, a friend was invited over. Jean-George came by fairly frequently.

George Auriol, after finishing a lecture at the Ecole Estienne, about 1935

The only regular social event at home was Madame Auriol's Saturday afternoon teas. For those, Auriol would rush home after his lecture at the Ecole Estienne to "tease" the ladies. He often "performed" for them, until his wife stopped him.

During the last few months of 1937, Auriol complained that he was "feeling lazy." He greatly reduced his activities along with his daily trips. He did, however, push himself to complete certain projects. A number of his book reviews were completed for the *A.B.C.* magazine. His notes for upcoming lectures were prepared. The design and printing of his Christmas card for 1937 was completed and sent out to friends and associates.

René Chennevière

Gustave Geffroy

I

By January, he felt so tired he had to remain in bed. On February 6, 1938, at 76 years of age, with his wife and son and a priest at his bedside, he died in his sleep.

Many years before, when he wrote for the *Chat Noir* journal, Auriol prepared a "Lettre des Morts," similar to a last will.

Please take note of my last wishes. I desire, when my soul will become weary of its body, to be lavishly embalmed. I wish to be clothed in a white gown. I do not want any coffin. That I be left on my bed to rest eternally with

flowers . . . but especially no purple flowers. . . . No regrets, no memories, no wasted wreaths . . . some lilies, some roses, some iris. That I be surrounded with books, with light. That I be overwhelmed with incense and beautiful music and that, above all, I be spared from the epitaphs.

Jean-George was extremely upset by his father's death. Some believe he never really recovered from it. He covered his studio walls with his father's art work and stories. After World War II, Jean-George sent out Christmas cards to friends and associates using the images his father had made in past years. Jean-George placed his name on the cards in much the same way his father had done before. Jean-George Auriol was killed by a car while walking near Chartres in April 1950.

Madame Auriol inherited all of Auriol's art work and writings that existed at the time. A little over a year after Auriol's death, however, she approached the Bibliothèque Nationale and offered to sell them the art work she had. They agreed and 258 pieces of work went to the library. Madame Auriol said she had to sell the work because she "needed the money."

Just after Auriol's death, the *A.B.C.* magazine devoted an entire issue to memorializing the man. Maurice Donnay wrote

It was in the fall of 1888 that I met George Auriol. He wrote tales in the newspaper Le Chat Noir *with a delightful imagination. We became friends rapidly. He had violent angers and sudden joys. He was quick to call someone names if he happened not to like him. He had spontaneous passions and instant admiration. Enthusiasm was his favorite state. If he found some joy reading a book, he invited you, rather, he incited you to read it.*

Rivière wrote of his friend

He had a very cheerful nature, exaggerated in all its ways, furiously paradoxical. He leaves delightful and varied art work, the souvenir of a warmhearted and true friend, a man wrapped up by beauty and with judgment.

Charles Peignot said

I saw George Auriol a few days before his death. Auriol had aged as one would hope to age himself, without anyone ever noticing it, and I found him looking like the memory I held of him since the first years of my youth. Auriol's name and his spirit are part of the web of my oldest memories.

Georges Lecomte, head of the Ecole Estienne, wrote

Man of taste, artist of all beauty, George Auriol was very sensitive to the way the works of the mind were naturally presented. He had a warm authority on hundreds of young people, gaining respect and affection, inspiring his students. I had many times urged him to write down his classes and draw the illustrations he used on the blackboard. But the gentle and stubborn man always found reasons to shy away. His solitude went beyond the decor of the cover and the typographical characters which he created.

And finally, his son spoke of the elements that tied him and his father so much together for over 30 years.

As early as childhood, I heard him ask people who came to ask him, for example, for a print, a monogram, if they were aware of the value of the gifts they were offering themselves. He was anxious to find out if they were capable of appreciating, not so much the quality of his work, but the element of pleasure they were going to enjoy. If he had their approval and if he was himself satisfied, all was well.

"I only want to imprint my writing paper," said the visitor, overwhelmed by the enthusiasm of the initiator. But my father would offer him a monogram, an icon gild, a buckle for his wallet, a stencil to imprint his handkerchiefs. . . . *"And you will also have to decorate your car. You don't have a car? But you are married, aren't you? So then you are not going to let your servant embroider any old initials on your pillow cases?"* The novice generally let himself down and did not leave before having heard one or two tales of the thousand and one nights, a few anecdotes, one recipe and without taking home with him a list of splendid books to read. . . .

This work performed and expected, my father would go across Paris ten times to keep an eye on the typography, the engraver, the printer, the stationer. . . . He was a worker, who, like the great workers of the past, knew the art of planning his canvas in order to paint his madonna. Generous, happy (he often sang while working), warm, carried away by contradictory bursts, he could go from a childlike carefree attitude to stormy anger; then, thirty seconds later, forget why he had flared up. One

found him to be paradoxical and partial because he was strongly logical. He condemned with the same impetuosity a foolish law and a badly written address on a letter: . . .

When he ceased to react with his customary violence, we should have guessed that his health was beginning to fail him. A short while before his end, he "just gave up." After 55 years of non-stop work, he did not admit this lassitude. "I feel a little lazy," he told the doctor: . . .

Always proud and anxious not to show himself weakened by a sickness which he felt was insignificant, he made a point to finish his Christmas cards on time, the ultimate testimony of his faithfulness towards hundreds of close and not so close friends. Despite a fatigue until now unknown to him, he went out a last time to give his classes at the Ecole Estienne. His last readings for the A.B.C. magazine as well as a few letters to students, he wrote them in bed, before accepting the absolute rest . . . and before entering, according to his own interpretation, "Nirvana."

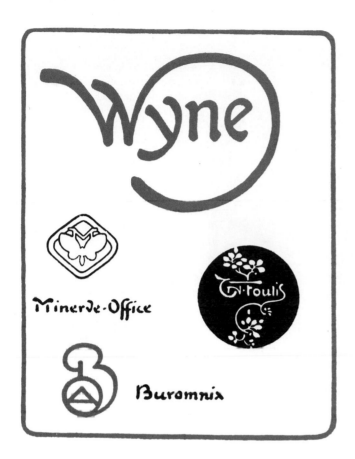

CATALOGUE RAISONNÉ

George Auriol
(1863-1938)

by Marie Leroy-Crevecoeur

Classification of Works:

1. **Prints** a) Woodcuts
 b) Lithographs
 c) Drypoint
2. **Theater Programs** a) Chat Noir
 b) Others
3. **Sheet Music Covers** a) Enoch
 b) Others
4. **Book Covers** a) Larousse
 b) Others
5. **Magazine Covers**
6. **Christmas Cards**
7. **Miscellaneous**–Menus, diplomas, programs, posters, advertisements

"L'Inventaire du Fonds Français après 1800," by Jean Laran (Tome I, Paris, M. Le Garrec, 1930) at the Cabinet des Estampes of the Bibliothèque Nationale, in Paris, catalogs only three pieces under the name of George Auriol:

> *"Bois frissonnants, Ciel étoilé"*
> *"Ornements typographiques," 3 pieces*
> *"Le 3ème Livre des Monogrammes, Cachets, Marques et Ex-Libris," Paris, Floury, 1924*

Actually, this inventory had been made before the Cabinet des Estampes purchased an important group of the artist's work from his wife in July 1939 (A. 09508). All the pieces are now regrouped with the number DC 468. Some programs for the Theatre du Chat Noir have the number Tb mat 3a, box #1 and some pieces are under S.N.R.

A certain number of pieces mentioned here are not included in the Cabinet des Estampes list nor from the public collection. The present catalog has been made possible through the assistance of dealers and private collectors. We mention, in particular, Mr. and Mrs. J. Enoch, Mr. F. Caradec, Bonafous-Murat, Christopher Drake, and Larousse.

In each section of this catalog, the pieces are chronologically ordered. At the end of each section, the pieces not dated are listed.

George Auriol's "Monogrammes, Cachets, Home-Marques"

These were presented in the "Premier Livre de Cachets, Marques et Monogrammes," Paris, Librairie Centrale des Beaux-Arts, 1901, prepared by Auriol. They are not described in the second and third volumes of "Cachets, Marques et Monogrammes."

Among the first eight monograms, five of them appear never to have been used, numbers 1, 2, 6, 7, 8. Numbers 3, 4 and 5 were used only during the "Chat Noir" period.

From 1888 to 1898, Auriol mostly used monogram 9, the insect (longicorn). In 1897, Auriol tended to use both monograms 9 and 10 on his work, often putting #9 on the front cover and #10 on the back cover.

From 1899 until his death, Auriol used only monogram #10, its enlargement #11, and his cachet #12.

I. PRINTS

A. Woodcuts

1. "The twin sisters"; woodcut; printed in 6 colors; 35x24.5 cm.; c.1892; monogram #9
Reproduced in "*Art et Décoration*," June 1899, p. 167
Could be #80 of the catalog of the show of the "Société des Peintres-Graveurs," Durand-Ruel's, 1893 (5th exhibition)

2. "Mother and Child"; woodcut; printed in colors; no signature, no monogram; 52x34.5 cm.; c. 1892
Reproduced in the catalog, "Japonismus und Art Nouveau," traveling exhibition in Japan, 1981, #70
Could be #81 in the catalog of the show of the "Société des Peintres-Graveurs," Durand-Ruel's, 1893. A trial proof of the key block exists in black, with no margins; no stamp, no signature, 32x23.5 cm.; no date

3. Fan; woodcut; printed in mauve-grey; c. 1892; monogram #9; 35x24.5 cm.
Could be #12 in the catalog of the show of the "Société des Peintres-Graveurs," Durand-Ruel's, 1893
In "*Art et Décoration*," June 1899, Arsene Alexandre speaks of a "beautiful series of fans, woodcuts, the title of one of them is both a shout of joy and war, 'Voici l'iris en fleurs!' "
Woodcuts with flower motifs, printed in black and white

4. Headpiece, for the foreword of Andre Marty's album, "l'Estampe Originale," 1893, monogram #9, 21x67 cm.

5./6. Frontispiece and identification tag of the "Album des Peintres-Graveurs," published by A. Vollard, 1896; monogram #9
Frontispiece: 12x18 cm.
Identification tag: 13x19 cm.

B. Lithographs

7. "Bois frissonnants, ciel étoilé," on a poem by Charles Cros; lithograph; printed in colors; part of Andre Marty's album, "l'Estampe Originale," 1893; edition of 100; monogram #9; 49x32.5 cm.
Exhibited as #1006 at the "Centenaire de la Lithographie," Paris, 1895, and as #1757 at the "Société Nationale des Beaux-Arts," Paris, Champ-de-Mars, 1895
There are proofs of the:

 Yellow stone
 Fawn, brown stones
 Fawn, brown, yellow stones
 Fawn, brown, yellow and gray-blue
 stones

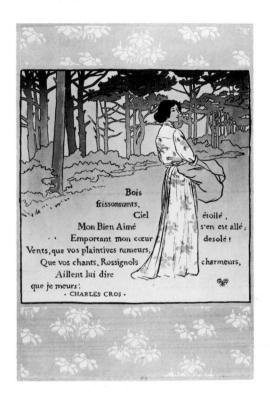

8. "Je suis celle qui ne veut pas dire son nom"; lithograph; printed in colors; c. 1894; in the stone; monogram #9; 32.5x30.5 cm.
Exhibited as #1005 at the "Centenaire de la Lithographie," Paris, 1895, and as #1756 at the "Société Nationale des Beaux-Arts," Paris, Champ-de-Mars, 1895

9. "Sur la plus haute branche, le Rossignol chantait" (Lady with a fan); lithograph; printed in colors; 1894; monogram #9 in the stone; 21x26 cm.
Exhibited at #1003 at the "Centenaire de la Lithographie," Paris, 1895, and as #1759 at the "Société Nationale des Beaux-Arts," Champ-de-Mars, 1895

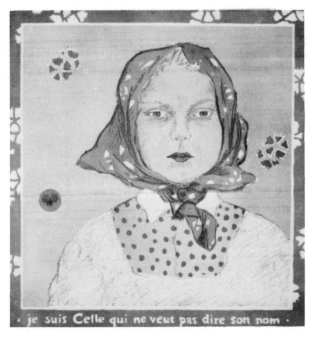

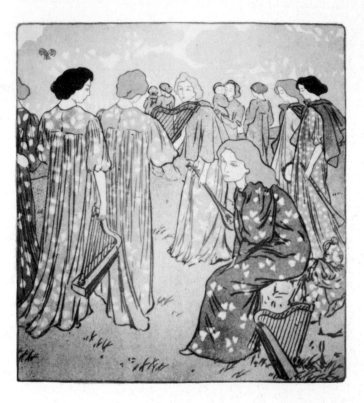

10. "Chansons d'Ecosse et de Bretagne" (or "La Musique"); lithograph; printed in 5 colors; 1895; monogram #9 in the stone; 26x24 cm. There are additional examples of this piece:

a) At Cabinet des Estampes of the Bibliothèque Nationale, an original drawing in ink of the same name, an indication for reducing it "en photolitho"; a group of young ladies, without any background; monogram #9

b) Proof of the keystone in black, with the letter

c) Proof of each of the five colors before letters:

> Green, with monogram #9 in the stone
> Yellow
> Blue
> Brown, with the background
> Red

d) Proof on Japon paper of the colors without the keystone, without letters. Could be #1004 "La Musique" at the "Centenaire de la Lithographie," Paris, 1895

Reproduced in "*Art et Décoration*," June 1899, p. 161

11. "Je hais le mouvement qui déplace les lignes"; on a poem by Ch. Baudelaire; lithograph printed in colors; published in A. Vollard's "l'Album des Peintres-Graveurs," 1896, edition of 100; monogram #9 in the stone; 46x25 cm.

Reproduced in "*Art et Décoration*," June 1899, p. 164

12. "Je veux de la poudre et des balles"; on a poem by V. Hugo; lithograph; printed in colors; published in A. Vollard's "l'Album d'estampes originales de la Galerie Vollard," 1897; monogram #9 in the stone; edition of 100; 47x26 cm.

13. "Selim, enfant de Damas"; lithograph; printed in 10 colors; published by A. Vollard, 1897; edition of 63; monogram #9 in the stone; 35.5x15.5 cm.
Trial proofs: Keystone, in grey; 9 color impressions minus the keystone
Reproduced in *"Art et Décoration,"* June 1899, p. 167
Also noted in "l'Estampe et l'Affiche," February 1897, "there is an impression of each stone separately, edition of 2 copies."

14. "Schéhérazade"; lithograph; printed in colors; published by *"Art et Décoration"* for a 1901 edition; monogram #9; 15x23.5 cm. The original drawing was completed in 1897.

15. "Head of a Young Lady"; lithograph; printed in 4 colors; #13, "Le Reliquaire"; published in an album of songs "Chansons d'Atelier" by Paul Delmet; 1901; monogram #10 in the stone; 23.5x13.5 cm.

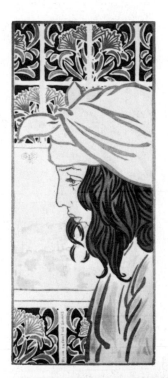

C. Dry-point

16. "Sitting young woman" (wearing a hat, in front of the sea); no signature, no monogram, no date; 18x10 cm.; c. 1888
A copy at the "Cabinet des Estampes" of the Bibliothèque Nationale. The style and subject matter are similar to the illustrated cover of the book, "Sur la plage," by J. Sarrazin, a poet and friend of Auriol.

II. THEATER PROGRAMS

A. The Chat Noir

Between 1889 and 1896, Auriol drew and lettered 15 covers of programs (3 of them unpublished) for the theater of the Chat Noir cabaret. Most sizes are 31.5x22.5 cm., except where otherwise noted.

17. "White poppies" (with large green leaves); printed in 2 colors; photomechanical process,

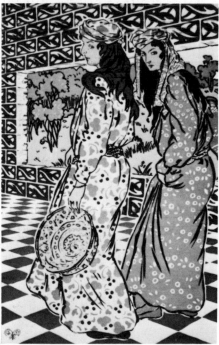

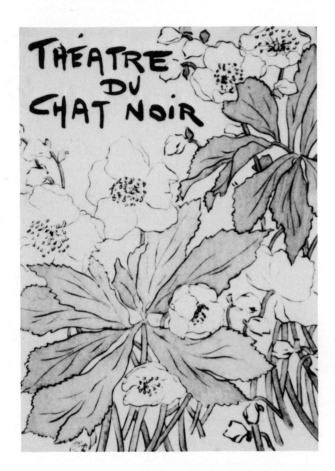

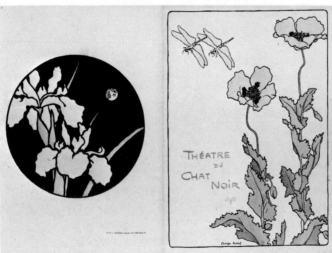

printed by Blot; signature and monogram #4 in the plate; 1889
Announces:
>"la Marché à l'Etoile"
>"l'Arche de Noé"
>"le Portrait du Colonel"

18. "Pink and yellow bindweed" (with blue-green leaves); printed in 2 colors; photomechanical process; initials in the plate but no monogram; 1889
Announces:
>"la Conquête de l'Algérie"
>"de Cythère à Montmartre"
>"le Casque d'Or"
>"la Rue"

19. "Young woman seated" (seascape in background); printed in black; photomechanical process; signature in the plate, no monogram; 1889
Reproduced in "Menus et Programmes illustrés," Paris, by L. Maillard; 1895; p. 330

20. "Three branches of chrysanthemums" (pink, yellow and orange with yellow-green leaves); printed in 5 colors; photomechanical process; signature and monogram #9 in the plate; 1890
Announces:
>"Phryné"
>"Les Oies de Javotte"
>"Roland"

21. "Two dragon flies and two poppies"; printed in 4 colors; photomechanical process; monogram #9; 1891
Announces:
>"Ailleurs"
>"le Carnaval de Venise"
>"Une Affair d'honneur"
Reproduced in "La Revue Encyclopédique," 1892, p. 148
Back cover—same motif; monogram #4, rare

22. "Two branches of white lilies"; printed in 2 colors; photomechanical process; signature and monogram #9 in the plate; 1892
Announces:

"Sainte-Geneviève"
"le Voyage Présidentiel"

Back cover — Branch of black and brown irises; monogram #9

23. "Large bunch of irises" (right of page); printed in colors; photomechanical process; signature and monogram #9 in the plate; 1893; 33x25 cm.
Announces:

"Héro et Léandre"
"Pierrot pornographe"
"le Secret"

Reproduced in *Art et Décoration,*" June 1899, p. 162

24. "Irises" (complete page); printed in colors; photomechanical process; monogram #9 in the plate; 1893
Announces:

"le Rêve de Zola"
"le Dieu volont"
"le Malin Kanguroo"

Reproduced in "Menus et Programmes illustrés," by L. Maillard, p. 331
Back cover — group of four girls, signed "manitou"; same as back cover of "La Vie Drole"; magazine, 1st issue; Nov. 25, 1893

25. "Cyclamens"; printed in black; photomechanical process; monogram #9, 1894
Announces:

"l'Enfant Prodigue"
"le Roi Débarque"
"Casimir Voyage"

Back cover — same flowers in a medallion; monogram #9

26. "Violet wisteria"; printed in colors; photomechanical process; monogram #9; 1895
Announces:

"le Sphinx"
"au Parnasse"
"Plaisir d'amour"

Reproduced in "Menus et Programmes illustrés"; by L. Maillard, p. 331

27. "Violet thyrsus" (with green leaves); printed in colors; photomechanical process; monogram #9; 1895
Announces:

"Clairs de Lune"
"l'Honnête gendarme"
"le 13ème travail d'Hercule"

28. "Bunch of irises" (in diagonal); lithograph; printed in colors; printer unknown; monogram #9; 1895; 36x26 cm.
Not the one represented in *"Art et Décoration,"* June 1899
Reduced size impression; 29x21 cm., printed in black and white

29. "Winter landscape" (with woman and child); photomechanical process; signature and monogram #9 in the plate; c. 1895; 31x22 cm.
Announces:
> "Phryné"
> "la Marche à l'Etoile"
> "le Voyage Présidentiel"

Back cover—white irises on black background

30. "Grapes, vine leaves and a bee"; photomechanical process, unpublished cover, without letters; monogram #5 in the plate; no date
This copy can be found at the Musée de Montmartre.

31. "Bunches of hydrangea"; original drawing in black India ink for an unpublished cover; letters down the left side; no monogram, no signature; no date; 29x21 cm.

B. Other Theater Programs

32. Flers Théâtre: "Grand Concert de Bienfaisance," March 25, 1888; printed in black; photomechanical process, printed by Blot; signature in the plate but no monogram; 29x22 cm.
Reproduced in "ABC Magazine," July 1938, p. 74

33. Théâtre Libre (branches, flowers of chrysanthemums); lithograph; printed in colors; signature and monogram #5 in the stone; 1889; 22.5x32 cm.

34. Gardenia Society: "Au Théâtre d'Application, 18, rue Saint-Lazare, samedi 30 décembre, 1893" (arrangement of hydrangeas and reeds, in white on blue); photomechanical process; printed in colors; monogram #9 in red

35. Renaissance theatre; lithograph; printed by Verneau, "editeur des estampes d'Henri Rivière," 1904-05; double page; monogram #10; 14.5x21 cm.

III. ILLUSTRATED SHEET MUSIC COVERS

George Auriol created more than 200 illustrated sheet music covers for the Enoch company between 1896 and 1931. A few sheet music covers were prepared prior to his affiliation with Enoch.

All of the covers bear an Auriol monogram. Most of the first ones have monogram #9, the others either monogram #10 or #11.

The size of the sheet is standard, 35x27 cm., except where noted.

The edition size is 300.

Some covers were printed in several colors. Auriol also drew all of the lettering, usually in one of the colors within the illustration. Up to 1914, all of the covers were lithographs; after the war, the photomechanical process was used.

List of the composers for whom Auriol completed covers

Alexandre-Georges
Antoine Banes
Rodolphe Berger
Angelin Biancheri
May H. Brahe
Paul Brunel
C. Chaminade
Camille Chevillard
André Colomb
Charles Cuvillier
A. Catherine & Ch. Fruster
Paul Delmet
A. Duval
Max Dolone
Cécile Dufresne
Louis Derivis
Georges Enesco

Edmond Filipucci
Fortolis
Georges Fragerolle
César Franck
H. Fleury
Noël Gallon
A. Gedalge
F. de Garnieri
E. Gillet
A. Gretchaninoff
Jenö Hubay
Marcel Hermitte
I. de Lara
Edmond Laurens
Raoul Laparra
André Lachaume
Wanda Landowska
P. Lacome
Charles Lévadé
Larmanjat
Mathilde Marchesi
André Messager
Henri Rabaud
Rob. R. Stewart
E. Paladilhe
I. Philipp
Mendelssohn
Albert Wolff

36. "Chansons pour la jeunesse"; by Paul Delmet (3 women standing, leaning on trees; blue letters on a beige background); lithograph; printed in colors; 1896; 29x20 cm.
Reproduced in the *"Catalogue général des Editions Epoch,"* Paris, 1900, and in *"Art et Decoration,"* February 1901, p. 74.

37. "Quinze chansons," by Paul Delmet (same cover as previous edition in different colors in a frame of thistles).

38. "l'Enfant Dieu," collection of old Christmas songs, music by Georges Fragerolle; lithograph; printed in colors; published by

Enoch and Flammarion; 1897.
The double-page hard cover (33x72 cm.) and the dust jacket have the same illustration; front cover—a seated Madonna and child, winter landscape; monogram #9; back cover—floral design on a sketchy landscape; monogram #10
Reproduced in "*Art et Décoration*," June 1899, p. 165

1897

39. "Quatre mélodies," music by Charles Cuvillier; large blue floral framing; exists in two other colors; monogram #9

40. "Nouveau printemps," five melodies by André Messager from H. Heine; blue ornamental motif.

41. "Bruit d'ailes," music by A. Catherine and C. Furster; stylized asters.

1898

42. "Cinq Intermezzi," music by R. Mandl; stylized red geraniums.

43. "Melodies," music by A. de Trabadelo; white iris on a light green background; monogram #9; 35x27 cm.
Reproduced in "*Art et Décoration*," June 1899, p. 162

44. "Melodies," music by Georges Enesco

45. "En effeuillant la marguerite," music by E. Laurens; three panels, young women, landscape.
Reproduced in "*Art et Décoration*," February 1901

46. "Divertissement sur des Chansons Russes," music by H. Rabaud; birds in a geometrical frame; printed in 2 colors.

47. "Dans les jasmins," music by A. de Trabadelo; jasmine and bindweed floral.

48. "Scherzo," music by J. Hubay; green leaves, pale pink framing and letters

49. "Ecole Marchesi–Mathilde Marchesi's method"; large framing of grey leaves

50. "10 pièces caractéristiques," music by J. H. Apple; tree branches, blue ornamentation

1900

51. "Oubli d'amour," music by C. Lévadé; floral motif, green and beige letters

52. "Les vielles de chez nous," music by C. Lévadé
Reproduced in *Art et Décoration*, February 1901, p. 70

53. "Désespérance," music by C. Lévadé; pink fuschias
Reproduced in *Art et Décoration*, February 1901, p. 70

54. "Poème pour la morte," music by C. Lévadé; hazeltree, two colors
Reproduced in *Art et Décoration*, February 1901, p. 70

55. "Prends cette rose," music by C. Lévadé; roses and green leaves
Reproduced in *Art et Décoration*, February 1901, p. 70

56. "Aurore," music by C. Lévadé; chrysanthemums
Reproduced in *Art et Décoration*, February 1901, p. 71

57. "Mirage," music by C. Lévadé; large floral framing

58. "Romances fanées," music by C. Lévadé; bindweed
Reproduced in *Art et Décoration*" February 1901, p. 71

59. "Jane," music by C. Lévadé; grass design

60. "Quand naissent les étoiles," music by C. Lévadé; stars in the sky, a Mediterranean landscape

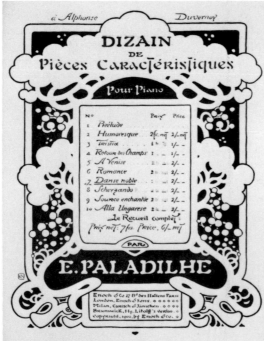

61. "Mélodies et poèmes," music by C. Lévadé; a collection of images from No. 14 to No. 23, including No. 41

62. "La lettre d'amour," music by R. R. Stewart (or "le Triomphe de Boldi"); two dragonflies on thyrsus

63. "Madrigal de Ronsard," music by C. Lévadé

64. "Caprices-Etudes, in octave," music by d'I. Philipp; large stylized frame; the same picture was used in 1920 on the cover "Exercises de vélocité" by the same composer

1901

65. "Chansons du Pays lorrain," music by G. Fragerolle; red dandelions
Reproduced in *Art et Décoration*, February 1901, p. 71

66. "Danse polonaise," music by W. Landowska; large branch of asters with blue leaves

67. "Rêverie d'automne," music by W. Landowska; red flowers with green leaves

68. "20 mélodies," music by C. Cuvillier, collection book; red and blue

69. "La chasse au furet," music by R. Laparra; 5 ferrets in the grass; this cover has been reproduced in different colors

70. "Des pas de sabots," music by R. Laparra; shoe tracks in the snow; this cover has been reproduced in different colors

71. "4 études de concert," music by M. Moszkowski; this cover has been reproduced in different colors

72. "Dizain de pièces caractéristiques," music by E. Paladilhe; large floral decorated motif

73. "Recueil de mélodies," music by C. Chaminade

74. "La bête noire," music by C. Lévadé; violet anemones

1902

75. "Scherzo de concert," music by E. Paladilhe

76. "Au pays d'amourette," music by C. Cuvillier; heads of women in line, landscape, within a large white framework on a beige background

77. "Entrée, sarrabande, et bourrée," music by C. Lévadé; sketchy landscape, within a large blue framework

78. "Dernière page," music by C. Lévadé; rose tree and branch of roses

79. "Au jardin d'amour," music by C. Lévadé; young woman standing at the edge of a pond

80. "Romances sans paroles," music by F. Mendelssohn; large frame of brown red poppies

81. "Le Chêne et le Roseau," music by C. Chevillard; oak tree and reeds in green

82. "Sept chansons de Clément Marot," music by G. Enesco; framework of green lucerne; there are small size copies—28×22 cm.

1903

83. "Les chansons de Miarka," collection of songs, music by A. Georges, poems by J. Richepin; geometrical decorative setting

84. "Paradis d'amour," music by C. Lévadé; large stylized floral framework

85. "Dans la forêt," music by A. Gedalge; meadow next to a forest

86. "Avril fleuri," music by C. Lévadé; hawthorn flowers

87. "Vers les étoiles," music by C. Lévadé; sea and landscape with gulls; has been reproduced in different colors

88. "Il neige," music by C. Lévadé; snow falling on flowered tree branches

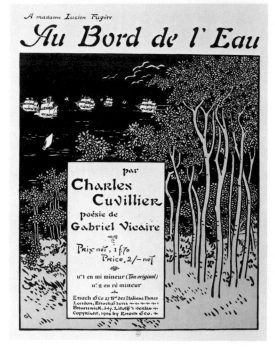

1904

89. "N'est-ce-pas," music by C. Chaminade; unusual geometrical pattern

90. "Cocorico," music by A. Lachaume; country landscape with farm and rooster

91. "Au bord de l'eau," music by C. Cuvillier; sea and landscape with sailing boats

92. "La claire fontaine," music by C. Lévadé; pond with irises and reeds

93. "Celle que nous aimons," music by C. Cuvillier; within a floral setting, portrait of a young woman

94. "L'oiseleur," music by C. Cuvillier; asters

95. "Comme les lys," music by C. Cuvillier; large white lily

96. "Ouvrez aux enfants," music by C. Cuvillier; red roses

97. "Colloque sentimental," music by C. Cuvillier; grey nocturnal landscape

98. "Sous la fenêtre," music by A. Lachaume; hazelnuts in blossom

99. "Musique sur l'eau," music by A. Lachaume; nocturnal landscape with birds, butterflies

100. "Chansons chinoise," music by C. Cuvillier; framework of green myrtle

101. "Pastorale pour piano," music by C. Chaminade; red clover

102. "La rose au rosier blanc," music by C. Cuvillier; in a country landscape, young woman by a rose bush

103. "Plainte sur la mort de Sylvie," music by C. Cuvillier; stream and willows

104. "Sonnet de DuBellay," music by C. Cuvillier; landscape and thatched cottage

105. "Départ," music by C. Chaminade; country landscape

106. "Son nom," music by C. Chaminade; bindweed

107. "Dans la nuit," music by C. Lévadé; stars and ferns

1905

108. "Lettre d'une pensionnaire," music by R. Berger; yellow and green mimosa

109. "Au bord des flots," music by L. Fortolis; sea and landscape, young woman standing near a cliff

110. "Amours lointaines," music by C. Cuvillier; white flowers with green leaves

111. "Vieux madrigal," music by C. Cuvillier; large triangular purslane

112. "C'était un soir," music by C. Cuvillier; grey framework with foliage

113. "Primevère," music by C. Cuvillier; primula and daffodils

114. "Rose d'amour," music by C. Cuvillier; pale roses

115. "Viens nous aimer," music by A. Lachaume; photographic portrait of a young woman, within a white frame

116. "Les Dragons de l'Impératrice," music by A. Messager; double page on blue paper with the same image as "Nouveau printemps"; 28x50 cm.

117. "Roussalka," music by H. Fleury; large white ornamentation

1906

118. "Ma vigne et ma Mie," music by C. Cuvillier; vines and grapes

119. "Floramye," music by A. Duval; large blue initials with lucerne

120. "Album des enfants," music by C. Chaminade, 1st series; three girls and a boy

121. "Promenade sentimentale," music by A. Gedalge; three peonies

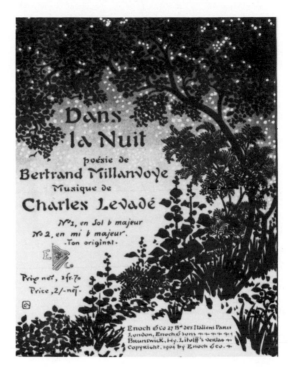

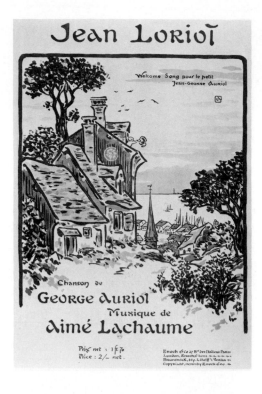

122. "Les Mouettes," music by C. Cuvillier; young woman, sea and landscape

123. "Sous la ramure," music by C. Cuvillier; large group of trees

124. "Nuit d'Ispahan," music by C. Cuvillier; city at night

125. "Les phalènes," music by A. Lachaume

126. "Les enfants pauvres," music by M. Dolonne

1907

127. "Jean Loriot," words by Auriol, music by A. Lachaume; welcome song for the birth of Auriol's son; sea and landscape, the Auriol's house at Saint-Valéry-sur-Somme

128. "Album des enfants," music by C. Chaminade, 2nd series; three children with musical instruments

1908

129. "Pastel pour piano," music by C. Chaminade; violet thyrsus

130. "Six chansons provençales," music by C. Dufresne; group of olives, young women's heads, crickets

131. "Poème provençal," music by C. Chaminade; garrigue and parasol pines; reduced size—28x23 cm.

1909

132. "Passacaille pour piano," music by C. Chaminade; elder trees

133. "Printania," music by A. Lachaume; red creeping plants

134. "Feuillets d'album," music by C. Lévadé; red flowers with green leaves

135. "Le papillon," music by C. Lévadé; stylized chestnut tree; this motif was used five other times, in different colors:

"Son charme"
"Inquiétude" (1910)
"Idylle parisienne" (1910)
"Rossignol, mon mignon" (1910)
"Ultime amour" (1910)

1910

136. "Etude scolastique," music by C. Chaminade; rose trees

137. "Menuet galant," music by C. Chaminade

138. "Ronde du crépuscule," music by C. Chaminade

139. "3ème gavotte pour piano," music by C. Chaminade; narcissus

140. "Voeu suprême," music by C. Chaminade

141. "Sérénade aux étoiles," music by C. Chaminade; thyrsus, blue starred night

142. "La barque d'amour," music by C. Lévadé

143. "Arlechino," music by C. Lévadé

144. "Barcarolle, Sérénade," music by C. Lévadé

145. "Pierrot joyeux," music by C. Lévadé

146. "Romance en ré," music by C. Chaminade; red honeysuckle

147. "Berceuse," music by C. Lévadé

148. "Marche americaine pour piano," music by C. Chaminade

149. "Capricietto," music by C. Chaminade

150. "Mazurka noble," music by C. Lévadé

151. "Suédoise," music by C. Chaminade; adorned initials

152. "Voici l'automne," music by L. Derivis

153. "Barcarolle vénitienne," music by L. Derivis

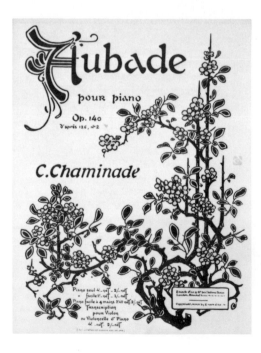

154. "Hymne à l'aurore," music by L. Derivis

155. "Ronde de lutins," music by L. Derivis

156. "Cortège pour piano," music by C. Chaminade; undulating landscape, pink clouds

157. "Aubade," music by C. Chaminade; branches of hawthorns

1912

158. "Douze pièces pittoresques enfantines," music by E. Filipucci; circus in a country landscape

159. "Feuille d'automne," music by C. Chaminade; cleared trees near a forest

160. "Scherzo caprice," music by C. Chaminade; brown and green ferns

161. "Je voudrais," music by C. Chaminade; stylized floral ornamentation

162. "Andante des 2 pigeons," music by E. Gillet; birds sheltered in a tree

163. "Délire," music by C. Lévadé

164. "Les Gabelous," opera-bouffe in 3 acts, music by A. Banès; bushes of cytisus

165. "L'Arche de Noé," operatorio by A. Banès; doves and arches

166. "Air espagnol," music by C. Chaminade; Spanish mountain

1913

167. "Souvenirs de jeunesse," music by R. Laparra; bush roses

168. "Rythmes espagnols," music by R. Laparra; cactus and foliage

169. "Les Bohêmiens," music by C. Chaminade; dragonflies, crickets, mushrooms and donkey

170. "Scherzo valse," music by C. Chaminade; yellow and green flowers

171. "La rôtisserie de la Reine Pédangue," music by C. Lévadé; vineyard, queen; in 1919,

the same cover was published without the vineyard

172. "Rêverie," music by A. Wolff; same ornamentation as in "Tyltyl" with 2 children

1914

173. "Ecossaise," music by C. Chaminade; Scottish landscape

174. "Interlude, pour piano," music by C. Chaminade; red roses and grey leaves

175. "Sérénade vénitienne," music by C. Chaminade

176. "Le village," music by C. Chaminade

1915

177. "L'anneau du soldat," music by C. Chaminade; ring and escutcheon of the town of Verdun

1916

178. "Dessous ta croisée," music by M. H. Brahe; tree in a pot in front of window

179. "Deux Marseillaises," music by N. Gallon

1918

180. "Comédie lyrique," music by A. Wolff

1919

181. "Berceuse du petit soldat blessé," music by C. Chaminade; soldier resting, Mediterranean landscape

182. "Danse païenne," music by C. Chaminade; 5 dancing "tanagras"

183. "Prière," music by A. Biancheri; adorned initials in blue

184. "Lever du jour," music by A. Biancheri; sun rising over a garden

185. "Villanelle," music by A. Biancheri; 2 doves and a basket of fruit

186. "Les heures roses," music by A. Biancheri; roses, apple tree and butterflies

187. "Ronde et giboulée," music by A. Biancheri; blossoming apple tree and mushrooms

188. "Aimez vos mères," music by A. Biancheri; vines and grapes

189. "Parfum exotique," music by A. Biancheri; young woman, seascape, basket of fruit

190. "La Habanera," music by P. Brunel

191. "Cheer Up," music by E. Filipucci; 4 pelicans and tippies

192. "Sept. poèmes" (la chanson des gueux), by J. Richepin, music by A. Biancheri; floral setting next to a little river

193. "Strophes et Interludes," music by I. de Lara; large rococo ornamentation

194. "Chanson d'Orient," music by C. Chaminade; monumental door in a far eastern city

195. "Au pays dévasté," music by C. Chaminade; birchwood on the road to Soissons

196. "La chanson de Tyltyl," music by A. Wolff; setting in a forest "Papillons dans la prairie," music by A. Biancheri; same image used as no. 172

197. "A la russe," music by A. Biancheri; bear and accordion

1920

198. "Daphné," music by C. Lévadé; Daphne, her legend, her laurel body

199. "Les sirènes," music by C. Chaminade; cliffs and mermaids

200. "Les elfes des bois," music by C. Chaminade; elves in the moonlight

201. "Impressions urbaines," music by A. Marotte

202. "Impromptu, pour piano," music by E. Chabrier

203. "3 poèmes," by R. A. Fleury, music by P. Lacome; large floral framework in blue

1921

204. "Suite facile pour piano," music by Larmanjat; the program inscribed on the leaves of a tree

205. "Scènes ibériennes," music by R. Laparra; town situated upon a cliff

206. "Chanson nègre," music by C. Chaminade; concert by 2 African musicians in a village

207. "Andalouse," music by E. Mignan

208. "Chants de Wallonie," music by Alexandre-Georges; dedicated, in gothic style letters: "A sa Majesté la Reine Elizabeth de Belgique qui a daigné accepter l'hommage de ces chants."

209. "Chants de Flandre," music by A. Gedalge; belfry and the arms of Flanders

210. "Chants de Rhénanie," music by A. Gedalge; fortified town overlooking the Rhine valley

211. "Gigue," music by F. de Garnieri

212. "Sicilienne," music by F. de Garnieri

213. "5ème gavotte pour piano," music by C. Chaminade; a young couple dancing in a meadow in 18th century dress

1922

214. "Duo d'amour," music by C. Lévadé; fortified village

215. "Berceuse de l'enfant riche," music by A. Biancheri; nurse and child in a wealthy setting

216. "Berceuse de l'enfant pauvre," music by A. Biancheri; mother and child in a poor setting

217. "Bel aubépin," music by A. Biancheri; hawthorn blossoms

218. "S'il est un charmant gazon," music by Cesar Franck

219. "Ave Maria," music by E. Filipucci; gothic style Madonna

220. "Mélodies," music by C. Chaminade; chestnut foliage and flowers

221. "7 Chansons," music by Georges Enesco; green and white clover

1923

222. "Mélodies, romances et chansons," music by C. Chaminade; red floral motif

223. "Romanesca," music by C. Chaminade; Italian lake

224. "Air à danser," music by C. Chaminade; young woman, group of dancing people

1924

225. "Berceuse," music by M. Hermitte

226. "Caprice-Impromptu, pour piano," music by C. Chaminade; marabouts and birds

227. "Ballade de la lune," music by A. Colomb; moonlight, women near a lake; 25x31 cm.

1925

228. "Berceuse arabe," music by C. Chaminade; palm trees, gazelles in a desert setting

1927

229. "Petite suite," music by C. Chaminade; Italian sea/landscape with domed church

230. "Interlude," music by C. Chaminade; pink, red and green ferns

231. "Lore Dantzariak," music by R. Laparra; hawthorn and vine leaves

232. "Messe," music by C. Chaminade; Gothic typography, floral red and black motif

233. "Rhapsodie russe," music by A. Gretcharinoff; Russian doll-like young woman

1928

234. "Paris, soleil du monde," music by M. Hermitte and H. Ackermans; emblem of Paris, Eiffel Tower, and mill

1942

235. "Rondes et chansons enfantines," collection of children's songs; publisher used a cover Auriol had drawn 20 years before

Not Dated

236. "Aubade," music by Georges Enesco; floral ornamentation; 28x25 cm.

237. "Les contes de Perrault"; village, cats, snails

238. "Etude humoristique," music by C. Chaminade

239. "Les débuts du pianiste," a collection of 100 melodies; floral yellow and blue ornamentation; 30.5x22.5 cm.

240. "Les pianistes de demain," "collection nouvelle de morceaux tres faciles"; pink and green wisteria

241. "Passacaille pour piano," music by F. Chuega

242. "Quatuor," music by L. Abbiate

243. "Serenata," music by J. Malats; Italian lake, pink and brown

244. "Six études de concert pour piano," music by C. Chaminade; stylized floral ornamentation

245. "Romances sans paroles," music by F. Mendelssohn

OTHER SHEET MUSIC COVERS

246. "A la Russarde, quadrille pour piano," music by G. Auvray; E. Fromont, publisher; 1887; equestrian standing on a horse, in a circus; signature in the plate but no monogram

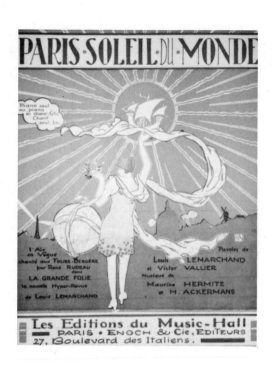

247. "Quand les lilas refleuriront," no. 8 in an album of 12 children's songs "Sur le pont d'Avignon," poem by Auriol, music by D. Dihau; Fouquet, publisher; 1889; photomechanical process; printed in colors; monogram #9; 35.3x27.5 cm.; street scene, young elegant women and little girls

248. "Chanson des 3 petits gueux," poem by J. Richepin, music by A. Gouzien; Paris, Chez Heugel et Cie; 1890; photomechanical process; printed in colors; monogram #9 in the plate; 32.5x25.5 cm.; 3 little boys in the sunset

249. "Chansons fleuries," collection by C. Blanc and L. Dauphin; Heugel et Cie; 1893; photomechanical process, printed by Gillot; printed in colors; monogram #9; young woman in a country landscape
Reproduced in "l'Art dans la décoration extérieure des livres," by O. Uzanne

250. "Rondes et Chansons d'Avril," collection of songs by C. Blanc and L. Dauphin; Heugel et Cie; 1893; proof of key in black; monogram #9; mosquitoes and irises

251. "Chansons d'Ecosse et de Bretagne," collection of songs by C. Blanc and L. Dauphin; Heugel et Cie; 1898; monogram #9 and #10; 23x31 cm., young woman leaning on the letters
Frontispiece—floral framework with the same woman as on the cover, leaning on the table of contents.
Original study drawing, in India ink, reproduced in *Art et Décoration*, February 1901, p. 73

252. "Vieilles chansons de France," Quinzard, publisher; 1898; photomechanical process, printed by Gillot; proof of the keyblock in black, proof in colors before letters; printed in colors; monogram #9; 20x30 cm.
Reproduced in the "Studio," no. XV

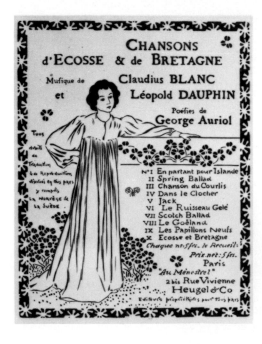

253. "Partridges March," à mon cher frère Emile; music by "H. D. de la M."; published by the Société Musicale G. Astruc; 1905; lithograph; printed in colors; monogram #11.

NOT DATED

254. "Chansons de France," collection of songs, music by G. Fragerolle; published by the Chat Noir; c. 1888; photomechanical process; printed in black on pale green silk; proof of the cover, in color, blue, white and red; signature but no monogram; 29x45 cm.

255. "Poupée, chanson crée par Mévisto," music by D. Dihau; Fouquet, publisher; photomechanical process, printed in brown; monogram #9.
Big format—32x27 cm.
Small format—25x18 cm., without the brown background and the framing
"Collection Orphée," Société Française d'Edition des Grands Classiques Musicaux, publisher

256. Bach, "le clavecin bien Tempéré"; monogram #10

257. Chopin, "Preludes," monogram #11
Stylized floral framework; 25x30.5 cm.

258. "Dansez, Chatez," collection of "chansons et danes mimées," by A. Chavannes, music by L. J. Rousseau; Librairie Larousse; monogram #11; in two sizes—32x24.6 cm. and 21.5x15.2 cm. Auriol also designed the 4 title pages for the 16 songs

IV. ILLUSTRATED BOOK COVERS

A. Larousse, from 1895 to 1930

George Auriol began to work for Larousse around 1895. He began preparing typographical ornamentation for the "Revue

Encyclopédique." In 1898, he started to design the illustrated book covers for their major encyclopedias. This often included the design of end papers and general ornamentation within the book.

Apart from the encyclopedias, most of the books were not dated. They all contained his monograms.

Larousse Encyclopedias

259. "Les sports modernes," 1905

260. "Le Musée d'Art," 1906, 2 vol.

261. "L'Espagne et le Portugal," by Jousset, 1908

262. "Le Belgique illustrée," by Dumont et Wilen, 1910

263. "Le Larousse Médical illustré," by Galtier-Boissiere, 1912

264. "La Hollande illustrée," by van Keymeuden, 1914

265. "Le Japon illustré," by Challay, 1914

266. "Le Larousse agricole," by Chancrin et Dumont, 1921

267. "Les Plantes," by Constantin et Faideau, 1922

268. "Le Larousse Universel," 1922, 2 vol.

269. "Les Animaux," by Joubin et Robin, 1923

270. "Le Ciel," by Berget, 1923

271. "Le Littérature Française," by Bedier et Hazard, 1923

272. "Paris et ses environs," by Dauzat et Bournon, 1925

273. "Histoire Générale des Peuples," by Petit, 1926

274. "Le Larousse Ménager," by Chancrin et Dumont, 1926

275. "L'Air," by Berget, 1927

276. "Le Larousse commercial illustré," by Clémentel, 1930

B. Larousse Miscellaneous

277. "La Bastille et Latude," Larousse et Leberlé; monogram #9; iris and 2 dragonflies Reproduced in *L'Art dans la Décoration Extérieure des Livres*, by O. Uzanne, 1898, p. 19

278. "Catalogue général de la Librairie Larousse"; lithograph; printed in colors "Mai, 1900," in orange and green on brown wove paper; monogram #9; 18x15.3 cm. "Catalogue 1900," in brown and black on a cream, woven paper; monogram #9; 42.3x32.5 cm.

279. "La pêche moderne," or "l'Encyclopédie du pêcheur"; monogram #10

280. "La chasse moderne," or "L'Encyclopédie du chasseur"; monogram #10; proof of this cover—40x30 cm.

281. "Routine et Progrès en Agriculture," by R. Dumont, 1914

282. "Memento Agricole," author unknown

283. "Le bagage scientifique de la jeune fille," by C. Juranville and F. Berger

284. "La Cuisine et la table modernes" Auriol Française typography and stylized branches of celery on the front cover; hazelnuts and mushrooms on the back cover; monogram #10; appears in 3 different colors

C. Larousse School Books
(All are printed in a photomechanical process)

285. Collection "la Nature en Images," by Faideau and Robin; monogram #10

286. "La terre et les êtres vivants"and " L'homme et les bêtes" Both with the same cover—landscape with gazelles and elephants; monogram #10

287. "L'homme et les animaux utiles"; landscape with shepherdess and her sheep; monogram #10

288. "Pierres et Terrains"; desert and stony landscape; monogram #10

289. "Plantes et Fleurs"; garrigue and parasol pine; monogram #10

290. "La Terre et l'eau"; sea and landscape with volcano; monogram #10

291. Collection "Histoire Naturelle," in 2 series
Series No. 1 uses the cover of "La Nature en Images" for

 "Géologie et Botanique"
 "Zoologie et Botanique"
 "Géologie élémantaire"

Series No. 2 was for "L'enseignement primaire supérieur"; it used the same illustration for all books but in different colors, according to the school level. Full page illustration of Japanese seascape; (Japonist style) fish, a central medallion, a turbanned man, a lion; monogram #11; 23.5x17 cm.

D. Illustrated Book Covers – Others

From 1887, Auriol collaborated with many publishers designing covers. In nearly all of these examples, Auriol prepared the illustrations and lettering by hand, using a brush and watercolors or inks. They were later transformed by the printers using the Gillotage (or photomechanical) process.

292. *Le Vice à Paris*, by P. Delcourt; Librairie Française, Piaget publisher; 1887; signature; 20.5x14.5 cm.; double page, in colors; naked woman, with a hat, standing on a pig (Auriol's first book cover)

293. *Le Vol à Paris*, by P. Delcourt; Librairie Française, Piaget publisher; 1888; signature; 20.5x14.5 cm.; young woman with an umbrella, sunset

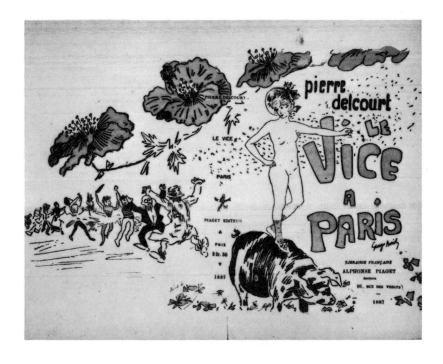

294. *Une idée lumineuse,* by A. Allais; monologue dit par Coquelin Cadet; Ollendorf; 1888; signature

295. *Album du Concours de Bruxelles*; 1888. Noted by A. Alexandre in *Art et Décoration*, June 1899, p. 167 (no other information)

296. *Courte et bonne,* by M. Colombier; printed in black and white; c. 1888; signature; a woman and young girl in a theater

297. *Le Chat Noir Guide;* Chat Noir, publisher; 1888; printed in colors; signature; elephant and circus ring

298. *Les Contes du Chat Noir — l'Hiver,* by R. Salis; Librairie illustrée, publisher; 1889; inside front cover, double-page spread; printed in colors; signature; young woman in a winter landscape

299. *Les Contes du Chat Noir — le Printemps,* by R. Salis; Dentu, publisher; 1891; inside front cover, double-page spread, printed in colors; signature; young woman and irises

From 1888 to 1894, Auriol illustrated book covers for his friend Jehan Sarrazin. Eighteen of them were published by Vanier's; 12 have been discovered. All the covers were printed using the photomechanical process; all were in color; all had Auriol's signature but no monogram; 35x21.5 cm.

300. *La Chanson de l'Hiver;* young woman and man, fainted young girl

301. *Le Journal de Jane;* foreword by Auriol; 22x32 cm.

302. *Histories Follichonnes;* 1888; white and blue checkerboard, figures and floral setting. Reproduced in *French Book Illustrators 1880-1905,* by Söderberg, p. 99
Original India ink drawing with indication for reduction of size; signed by the artist

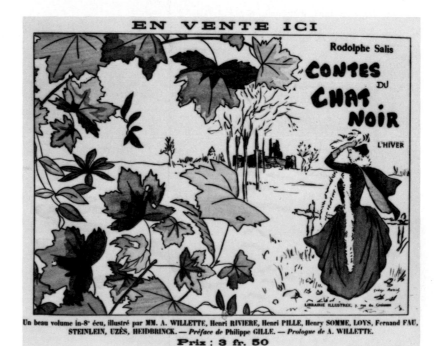

303. *La Ballade du Printemps,* young woman in front of a tree and haystack
Original India ink drawing with indication for reduction of size; signed by the artist

304. *Fleur des Pois;* woman seated in front of a fence
Original India ink drawing with indication for reduction of size; signed by the artist

305. *Le Coffret de Gigolette;* divided cover, woman in each section

306. *Sous-bois* or *Les Mémoires d'un bouvreuil indiscret;* bullfinch sitting on a branch
Original India ink drawing with indication for reduction of size; signed by the artist

307. *Sur la plage;* upper section—floral ornamentation; lower section—backs of 2 women, with hats, seated in front of the sea

308. *Les 7 nuits de Zaïra;* young woman wearing a kimono
Original India ink drawing with indication for reduction of size; signed by the artist

309. *La Moisson fleurie;* women, children and bindweed

310. *Aubanel;* women and children near the water

311. *Les Farces de Mijoulet;* Lambert, publisher; 1894; monogram #9; 30x20 cm., double page—bunch of irises; impression with and before letters

312. *French Illustrators,* by L. Morin; Scribner's, New York; 1893; photomechanical process; printed in colors; monogram #9; 34.5x27 cm.
Each of the 5 brochures of the volume are illustrated by a different artist. Auriol drew the cover for section II as well as the head bands and the lettering for sections II and III
Reproduced in *L'Art dans la Décoration Extérieure des Livres,* by O. Uzanne; 1898; p. 79

313. *Les Yeux Clairs,* by G. d'Esparbès; Dentu, publisher; 1894; photomechanical process; printed in colors; monogram #9
Reproduced in *French Book Illustrators 1880-1905,* by Söderberg, p. 99

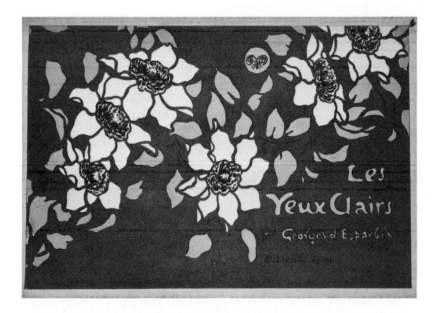

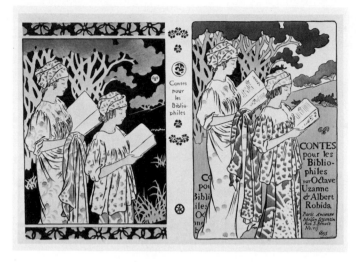

314. *L'Embarquement pour Ailleurs,* by G. Mourey; H. Simonis Empis, publisher; 1895; photomechanical process; printed in colors; monogram #9; a bunch of irises
Reproduced in *L'Art dans la Décoration Extérieure des Livres,* by O. Uzanne, 1898, p. 50

315. *Chansons naïves et perverses,* by G. Montoya; Ollendorf, publisher; 1895; typographic cover; monogram #9; woman with long hair and thatched cottage
Reproduced in *L'Art dans la Décoration Extérieure des Livres,* by O. Uzanne, 1898, p. 49

316. *Répertoire de la coopérative des Professions libérales;* monogram #9; blue floral ornamentation on white background with red letters

317. *Contes pour les bibliophiles,* by O. Uzanne and A. Robida; Quantin, publisher; 1895; double-page cover; photomechanical process; printed in colors; monogram #9; 19x24 cm. Large format impression of the keyblock in black, 38x55 cm.
Reproduced in *Art et Décoration,* June 1899, p. 163

318. *Mimes,* by M. Schwob; 1895; monogram #9; floral motif on a beige background

319. *La Belle d'Août;* by A. Marin; Ollendorf, publisher; 1897; lithograph; printed in colors; double-page cover; monogram #9 on front cover, monogram #10 on back cover; 24.6x15.7 cm.; woman walking with a jug in her hand in a forest

320. *Le Thyrse,* by A. Goffin; Vos, publisher, Bruxelles; 1897; impression in colors on grey paper; monogram #9; 20.5x17 cm.

321. *Les Premières fleurs,* by G. Auriol (*Les leçons de chose du petit coloriste*); H. Laurens, publisher; 1901; a coloring book for children

322. *Les Modes de Paris,* by O. Uzanne; Société Française d'éditions d'art, publisher; 1898; double-page cover; photomechanical process; printed in colors; monogram #9 on front cover,

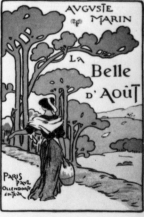

monogram #10 on back cover; 23x37.5 cm.; large size impression: 33.5x55 cm.

323. *Les Bucoliques*, by J. Renard; Ollendorf, publisher; 1898; double-page cover; lithograph; printed in colors; monogram #9 on front cover, monogram #10 on back cover; 17x20.5 cm.; landscape with geese

324. *Le Cyclisme*, by J-H Rosny; 1898; trial proof in black and white; monogram #10; 14x9 cm.; tree and floral ornamentation
Reproduced in *Art et Décoration*, June 1899, p. 168

325. *Catalogue Général des Editions Enoch;* 1900; lithograph; printed in colors; trial proofs with and before letters; monogram #9 and #10; 32.5x48.3 cm.; floral ornamentation

326. *La Décoration et les Industries d'Art à l'Exposition Universelle de 1900*, by R. Marx; Delagrave, publisher; 1900; double-page cover; lithograph; printed in colors; trial proofs with letters, before letters; monogram #9; 33x27 cm.

327. *Le Louvre et la Peinture*, by G. Geffroy; Per Lamm, publisher; 1901; photomechanical process; printed in colors; trial proofs with letters; monogram #11; 32.5x27 cm.; colonnade and temple

328. *La National Gallery*, by G. Geffroy; Per Lamm, publisher; 1901; front and back cover, gold lettering, embossed, printed on black leather; monogram #11; 26.5x20 cm.; floral design

329. *Les Combinaisons Ornementales*, by Mucha, Verneuil and Auriol; 1901; lithographs; printed in color; monogram #10; 24x26 cm.; floral design and ornamentation by each artist
Advertisement in *Art et Décoration;* February 1901

330. *Le Premier Album du Gardenia;* 1901; lithograph; printed in colors; monogram #10; 18.2x24.3 cm.

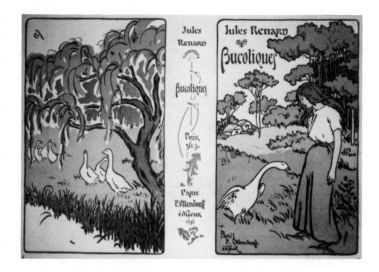

331. *Le premier livre des Cachets, Marques et Monogrammes,* by G. Auriol; Librairie Centrale des Beaux-Arts, publisher; 1901; double-page cover in black on pink paper; front cover — two women leaning on the publisher's mark; monogram #9; back cover — a woman holding a basket printed with Auriol's mark; monogram #10; 19.5x14.5 cm.

Trial proofs of the inside plates before reduction of size:

In black, 55x40 cm., about 100 monograms; in red, 55x40 cm., about 50 monograms

332. *Les deux femmes,* by J-H Rosny; Ollendorf, publisher; 1902; monogram #10; floral ornamentation

333. *Trop jolie,* by R. Maizeroy; Ollendorf, publisher; 1902

334. *Les Trente-Six Vues de la Tour-Eiffel,* by H. Rivière; Verneau, printer; 1902; double-page cover; lithographs; printed in colors; inside lettering, ornamentation and end papers; outside embossed impressions in color; boxed; monogram #10; 23x29 cm.

335. *Sourires de Jadis,* by L. Dauphin; Messein, publisher; 1904

336. *Albert Besnard,* by G. Mourey; H. Davoust, publisher; 1905; large flowers in 3 colors

337. *L'Imprimerie et les procédés de gravure au XXème siècle,* by A. Marty; chez l'auteur, rue Duroc; 1906; monogram #10; floral ornamentation

338. *Henri Rivière, Peintre et Imagier,* by G. Toudouze; Floury, publisher; 1907; double-page cover; lithograph; printed in colors; monogram #10; 38.5x27 cm.; irises

339. *Le second livre des Monogrammes, Marques, Cachets et Ex-Libris,* by G. Auriol; Floury, publisher; 1908; double-page cover; lithograph; printed in colors; monogram #10; 19.5x14.5 cm.

340. *L'Art le Boulevard et la Vie,* by G. Maurevert, Nice, N. Chini, Paris; Floury, publishers; 1911; monogram #11

341. *Histoire Universelle illustrée des pays et des peuples,* Quillet, publisher; 1913; monogram #11

342. *Le troisième livre des Monogrammes, Marques et Ex-Libris,* by G. Auriol; Floury, publisher; 1924; double-page cover on grey paper; monogram #10; 14.5x19.5 cm.

NOT DATED

343. *Les Chansons de Bilitis,* by P. Louÿs; trial proofs of the keyblock in black; 23.2x42.2 cm.

344. *La Bretagne,* by A. LeBraz (in the "Provinces Francaises" from the "Anthologies Illustrées" series); Laurens, publisher; monogram #11; wheat plants
Cover also used on: *Bourgogne, Alsace, Le Dauphiné,* etc.

345. *Les Etablissements Ruckert & Cie.;* trial proofs of the cover; front cover—blue ornamentation with red letters; monogram #10; 30x22 cm.; back cover—18x12 cm.

346. *Brelan de Salons,* by Hoschedé; mentioned by A. Alexandre in *Art et Décoration,* June 1899, p. 168

347. *Sapho,* unpublished cover for A. Daudet's novel; double-page cover; photomechanical process; printed in black; proof of keyblock in black; black letters; monogram #10; 30x45 cm.; floral poppies

V. ILLUSTRATED MAGAZINE COVERS

348. *la Vie Drôle;* 1893; literary manager, A. Allais, editor, G. Auriol; headband with floral ornamentation in black on white; photomechanical process; monogram #9; 29x20.5 cm.

349. *La Lecture illustrée;* 1896
Reproduced in *Art et Décoration*, June 1899, p. 168

350. *L'Image — revue mensuelle artistique et littéraire. Ornée de figures sur bois;* January 1892, No. 2; woodcut; printed in color; monogram #9; 30x23 cm.

351. *L'Estampe et l'Affiche*, 2ème année, 1898; Clément-Janin, editor; monogram #9; black setting and red letters
Reproduced in *Art et Décoration*, June 1899, p. 168

352. *La Revue Encyclopédique*, Larousse, publisher; from 1891-1901; vegetal frame and letters; one color on white; photomechanical process; monogram #9

353. *La Revue Universelle;* Larousse, publisher; from 1901-1907; floral ornamentation and letters; one color on white; photomechanical process; monogram #10

354. *Cocorico*, February 1902; lithograph; printed in colors; monogram #11; 22x16 cm.; turbanned young man with long hair

355. *Les Arts de la Vie;* July 1904, No. 7; Larousse, publisher; photomechanical process; printed in color; monogram #10; 16x22 cm.

356. *L'Art à L'Ecole;* from 1908-1938; no monograms; floral ornamentation and letters

NOT DATED

357. *La Revue Franco-Américaine;* printed in color, red letters; monogram #9
Mentioned in *L'Art dans la Décoration Extérieure des Livres*, by O. Uzanne, 1898, p. 48

358. *L'Epreuve photographique: No. 12;* Plon Nourrit et Cie, ed.; P. Aubry, editor; lithograph; printed in colors on grey paper; monogram #11; 44.5x32 cm.; large floral ornamentation and seascape

359. *La Semaine illustrée;* unpublished cover Reproduced in *l'Art dans la Décoration Extérieure des Livres,* by O. Uzanne, 1898, p. 77

360. *Three lilies;* unpublished cover; lithograph; printed in colors; printed by Verneau; monogram #9; 30x23 cm.

The unpublished *Dictionnaire des Illustrateurs* by Druart mentions covers drawn by Auriol in the following magazines: (to date, none have been found)

> *La Lanterne Japonaise*
> *Lumina*
> *Le Magazin Français*
> *Le Moniteur de 1900*
> *L'Echo Littéraire du Boulevard*
> *L'Art Décoratif*
> *Le Journal des Artistes*

VI. CHRISTMAS CARDS

Starting in 1898, and continuing until his death in 1938, Auriol created, printed and sent Christmas cards to friends and business acquaintances.

All cards were lithographed, printed in four or five colors. They were all approximately 17.5x11.5 cm. in size. The first card had monogram #9 and #10; the remainder of the cards had monogram #10 or #11 used interchangeably. All letters on the cards were hand-printed by Auriol.

The text of the cards is either:

> "Les meilleurs souhaits de M. et Mme. G. Auriol" or
> "Les meilleurs voeux de M. et Mme. G. Auriol"

361. 1898—Long black figure of a woman standing holding an envelope, with monogram

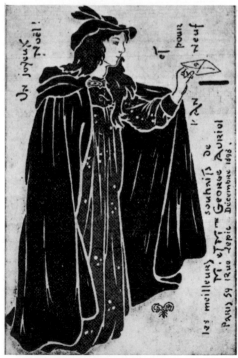

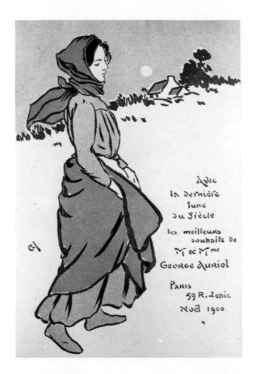

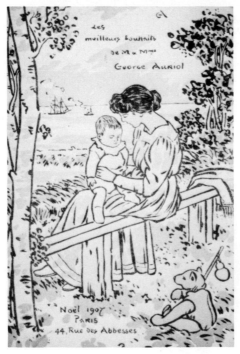

#10; includes words "un joyeux Noël et, pour l'an neuf"; monogram #9
Reproduced in *A.B.C. Magazine*, July 1928, p. 78

362. 1899–Two standing women in a winter landscape
Reproduced in *La Revue Encyclopédique*, Larousse, 1900, p. 60

363. 1900–Young woman standing, a small house in the background; includes words "avec la dernière lune du siècle"
Reproduced in *Art et Décoration*, January 1902, p. 5
1901–not identified
1902–not identified

364. 1903–Woman leaning on a rock; includes words "bon an bon soleil et le reste"
Reproduced in *A.B.C. Magazine*, July 1938, p. 78
1904–not identified

365. 1905–Woman holding a jug, in a winter landscape
1906–not identified

366. 1907–Woman and child; seascape; the baby is Jean-George Auriol, the artist's son, born July 1907. (He appeared in these cards each year through 1919.)
Reproduced in *A.B.C. Magazine*, July 1938, p. 78

367. 1908–Seascape, woman and young child

368. 1909–Little boy and rabbit playing with a toy train
Reproduced in *Art et Décoration*, March 1910, p. 55
1910–not identified
1911–not identified
1912–not identified
1913–not identified

369. 1914–Two boys and various animals in a winter landscape; includes words "Tant crie-l'on Noël qu'il vient"
1915–not identified

370. 1916–Boy sitting on tree branch, with squirrels and a large snail

371. 1917–Two boys shooting bow and arrows

372. 1918–A boy pulling up the French, English and American flags; background port, seascape

373. 1919–Two boys climbing a scaffolding to repair a weathercock

374. 1920–Herd of elephants; oriental setting
Represented in *La Lettre d'imprimerie*, by F. Thibaudeau, 1921, Vol. 2

375. 1921–Four women seated by the sea, sail boat in background

376. 1922–Country woman walking in a winter landscape

377. 1923–Two women sitting by the sea, watching the horizon

378. 1924–Five women collecting branches in a wooded area

379. 1925–Three women collecting wood; sea and landscape in background

380. 1926–Three women walking in a grassy area near the sea

381. 1927–Group of women working near the shore; wooded area in background

382. 1928–Group of women harvesting grain in the field

383. 1929–Nicely dressed woman looking at sail boats in the wind

384. 1930–Group of country women carrying baskets on their shoulders

385. 1931–Sitting shepherdess, flock of sheep, overlooking a river with barges

386. 1932–Women hanging laundry on a windy day

387. 1933–Woman rowing a boat; sailing boats in background

388. 1934–Seated women looking at sailing boats at dusk

389. 1935–Women and child carrying flower baskets near a river

390. 1936–Two women seated under a tree, looking at a passing boat at night

391. 1937–Two women carrying baskets near a river
Reproduced in *A.B.C. Magazine*, July 1938, p. 78

In 1946, Jean-George Auriol began sending Christmas cards to friends. Each of them represented one of his father's drawings.

392. 1946–Two women seated, looking out to sea (same motif on the cover of the novel *Sur la plage*)
1947–not identified

393. 1948–Woman standing, winter landscape
Reproduced in *La Revue du Cinéma*, new edition, 1980

394. 1949–Woman standing, her hand on a table (same motif on the invitation for a dinner of the Société du Gardénia, February 1899)

VII. MISCELLANEOUS

A. Programs and Invitations

395. "Un programme pour une fête donnée au Ministère de la Marine"

396. "Bal du bénéfice de l'Association des Artistes dramatique" (à l'Opera); 1888; printed in colors
Mentioned in "Menus et Programmes illustrés," by L. Maillard, p. 331

397. "Paris-Anvers," program for the musical festival in Anvers; lithograph; printed in black and white; signature; c. 1890; 48.5x20.5 cm.

398. "Programme de la soirée du 22 Mars 1890"; lithograph; printed in colors; double-page cover; impression of the keystone in black; woman walking in front of and behind a window; 26.5x38 cm.; signature

399. "Dîner du Gardénia du 18 Février 1899"; invitation; lithograph; printed in colors; monogram #10 in the stone; 19.7x22.5 cm.

400. "Souper du 20 Mars 1902"; invitation; lithograph; printed in colors; printed by Verneau; monogram #10; 24.5x16.5 cm.

401. "15 Avril 1907," program of the evening; lithograph; printed in colors; no monogram, no signature; 25x32.7 cm.

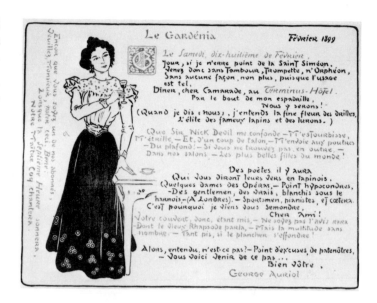

B. Menus

402. "Chat Noir"; photomechanical process; printed in colors; printed by Blot; monogram #4; before 1895; 35x25 cm.; seated woman eating, country landscape with sheep; this menu was printed in several colors

403. "Les Cent Bibliophiles"; lithograph; printed in colors; December 1907; monogram #11; 20x15 cm.; birch trees and mushrooms

404. "Le Livre contemporain"; lithograph; printed in colors; February 1909; monogram #10; 15.8x24.7 cm.; birch tree leaves and fruit

405. "Dîner des Libraires"; lithograph; printed in colors; April 1909; monogram #11; a little girl reading under a tree
Reproduced in *Art et Décoration*, March 1910, p. 100

406. "Messieurs les Libraires de France"; photomechanical process; printed in colors; May 26, 1914; monogram #11; 17x36 cm.

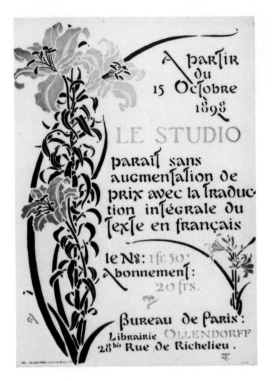

407. "Les Cent Bibliophiles"; lithograph; printed in colors; no date; monogram #11; 27x18.5 cm.; two women sitting under a tree

408. Proposed menu, before letters; lithograph; no date; monogram #11
Reproduced in *Art et Décoration*, June 1899, p. 168

C. Posters

409. "The Studio" (French edition of the British magazine); Librairie Ollendorf; printed by Verneau; October 1898; lithograph; printed in colors; monogram #12; 60x38 cm.
Reproduced in *Das Frühe Plakatin Europa und den U.S.A.* vol. 2, no. 26, France and Belgium Large format, 80x39 cm.

410. "Akademos" (revue mensuelle d'art libre et de critique); printed by Verneau; January 1909; lithograph; printed in colors; monogram #11; 59x80 cm.; Mediterranean landscape and letters framed in a band of Greek ornamentation

411. "Pour la séparation des Beaux-Arts et de l'Etat"; (lire dans "les Arts de la Vie"); printed by Verneau; not dated; lithograph; printed in colors; no monogram; no signature; no date; 120x90 cm.

412. "Brasserie des Martyrs," les soirs, Le Guignol Lyonnais; lithograph; printed in colors; no date; signature; 40x55 cm.

413. "Le Diablotin," journal humoristique, littéraire, artistique illustré; photomechanical process; 1891; monogram #5; 23x49 cm.

414. "L'Enfant-Dieu"; front cover of the book, before letters; lithograph; printed in colors; printed by Verneau; 1897; monogram #9; 22.5x45 cm.
Reproduced in *Das Frühe Plakat. . .*, vol. 2, no. 26

415. "Les Estampes Décoratives d'Henri Rivière"; lithograph; printed in colors; printed by Verneau; c. 1898; monogram #10; 24.3x33 cm.; exists with and before letters
Reproduced in *Das Frühe Plakat. . .*, vol. 2, no. 27

416. "Paris-Atlas, un fascicule à 75, chaque samedi"; Larousse; 1905; photomechanical process; printed in colors; monogram #10

417. "L'Hiver" (1er volume des Contes du Chat Noir, de R. Salis); photomechanical process; printed in colors; signature; 1889; 35x26 cm.

D. Advertisements

418. "La Brasserie Fontaine (Soupers Taverne du Corin Diner Concert); photomechanical process; printed in black and white; 1888; signature; 14x11 cm.

419. "Les Etablissements Porcher" (creation of new rooms for exhibition); photomechanical process; printed in colors; 1900; monogram #10; 22.5x15 cm.

420. "Les Atlas de poche"; lithograph; printed in colors; trial proofs before letters; c. 1900; monogram #10; 44x32 cm.

421. "Carméine" (brochure for toothpaste); double-page illustrated cover; photomechanical process; c. 1902; monogram #10; 18x8 cm.

422. "Inondés"; framework for a picture on a poem by J. Sarra; photomechanical process; printed in black and white; before 1895
Reproduced in "Menus et Programmes illustrés," by L. Maillard

423. "Le Capitaine Longoreille"; Auriol's last novel; Berger-Levrault, editors; 1921; 13.4x10 cm.

424. "L'Annonce Illustrée"; 1917; monogram #9
Reproduced in "Les Arts Français"; 1917

425. "Grande Laiterie de Montigny Vingeanne"; gillotage; monogram #9; 24.5x19.5 cm.

E. Birth Announcements

426. Marie-Louise "Monsieur et Madame Maurice Lemesle sont heureux de vous faire part de la naissance de leur fille; Paris, 6 janvier 1900, 25, rue de Rocher"
Reproduced in *Art et Décoration*, March 1910, p. 101 and in *Revue Encyclopédique*, Larousse, 1900

427. Jean-George Auriol "M. et Mme. G. Auriol sont heureux de vous annoncer la naissance de leur fils Jean-George, Paris, 44, rue des Abbesses, le 8 Janvier 1907"; photomechanical process; printed by Gillot; monogram #10; 12x9 cm.
Reproduced in *Art et Décoration*, March 1910, p. 101 and in *Manuel Français de typographie Moderne*, by F. Thibaudeau, 1924, p. 442

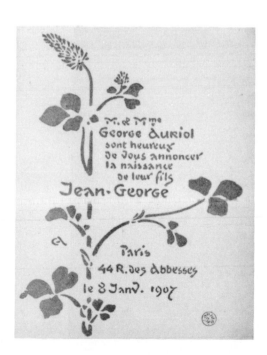

428. Henri B "M. et Mme. Edmond Becker sont heureux de vous annoncer la naissance de leur fils Henri, Paris, 8 rue Fromentin, le 28 Juin, 1902"
Reproduced in *Art et Décoration*," March 1910, p. 101

429. Robert L "M. et Mme. André Laurent ont la joie de vous annoncer leur fils patiemment attendu est arrivé à bon port le 31 Août 1923, 188, rue du Château, 79 rue Madame"; photomechanical process; printed by Gillot
Reproduced in *Manuel Français de typographie Moderne,* by F. Thibaudeau, 1924, p. 442

F. Diplomas

430. "Concours de dessin du Journal" (diploma of honor); photomechanical process; printed in colors; monogram #9; 1897; 32.8x45.5 cm.

431. "Chambre Syndicale du Commerce"; diploma en Gros des vins et spiritueux; lithograph; printed in colors; printed by Verneau; no date; signature; 40x50 cm.

432. Marque-Page; pour la maison Larousse
Reproduced in *Revue Encyclopédique*, 1897, vol. VII, no. 174, p. 9

BIBLIOGRAPHY
———

Periodicals

A.B.C. Magazine, "George Auriol"; Paris; No. 162; July 1938; pp. 73-84

Alexandre, Arsene; "George Auriol"; *Art et Décoration;* 5 (June 1899), pp. 161-170

L'Art et Les Artistes; October 1907; p. 324

L'Art et Les Artistes; November 1909; p. 96

Les Arts Français; Paris; 1917; p. 76, p. 209

Auriol, G.; *Le Chat Noir Journal;* Paris; 1884; articles appearing in issues no. 141, 142, 143, 145, 146, 147, 148, 149, 150, 151, 152, 153, 154

Auriol, G.; "Steinlen"; *Les Arts Français;* Paris; no. 3; pp. 43-48; 1917

Auriol, G.; "Le Théâtre du Chat Noir"; *Le Revue Encyclopédique;* Librairie Larousse; 1893; pp. 37-39

Auriol, G.; "Jean Loriot"; lyrics to song; Paris; Enoch; 1907

Bing, Sigfried; "l'Art Nouveau", *The Architectural Record;* New York; vol. XII; 1902; pp. 279-85

Bouyer, R.; "Papiers à lettres"; *Art et Décoration;* Paris; vol. 7; 1900; pp. 51-54

Caractère; "Deberny et Peignot, la belle époque de la typographie"; Paris; 1980; pp. 31-53

Caradec, F.; "George Auriol"; *Caractère;* Paris; no. 75; December 1981; pp. 20-29

Champier, V.: "Les expositions de l'Art Nouveau"; *Revue des Arts Décoratifs;* Paris; vol. XVI; 1896; pp. 1-16

Darthonnay, M.; "George Auriol"; *Larousse Mensuel;* Paris; no. 377; July 1938; p. 151

Garnier, E.; "Ceramic Plate Designs"; *Art et Décoration;* Paris; December 1901; p. 86

Garvey, E.; "Art Nouveau and the French book of the 1890's"; *Howard Library Bulletin;* vol. 12; 1958; pp. 375-91

Grasset, Eugène; "l'Art Nouveau"; *Revue des Arts Décoratifs;* Paris; vol. XVII; 1897; pp. 129-44, 182-200

Guillemot, M.; "Vignettistes"; *Art et Décoration;* Paris; March 1910; pp. 99-110

L'Image: revue littéraire et artistique, ornée de figures sur bois; Paris; H. Floury; December 1896-November 1897; Auriol drew January 1897 cover

Maindron, E.; "La petite Estampe"; *Revue Encyclopédique;* no. 174; Paris; Larousse

Marx, R.; "Notes sur les Peintres-graveurs"; *L'Artiste;* Paris; vol. 127; April 1893; pp. 286-292

La Revue du Cinéma 1928-1931 1946-1949; Paris; Pierre Lherminier Éditeur; 1979; pp. xi-xxii

Saunier, C.; "Papiers de garde de George Auriol"; *Art et Décoration;* 1912; pp. 47-50

Soulier, G.; "Quelques couvertures de George Auriol"; *Art et Décoration;* Paris; vol. 9; 1901; pp. 69-76

The Studio; "Some Designs for Ex-Libris"; London; March 1914; pp. 53-59

Verneuil, M.; "De l'emploi de la Couleur en impression"; *Art et Décoration;* Paris; January 1902; pp. 1-12

La Vie Drôle; no. 1; Nov. 25, 1893

Vitry, P.; "L'Art à l'École"; *Revue des Arts Décoratifs;* Paris; July 1904; pp. 51-56

Books

Antoine, André; *Mes Souvenirs du Théâtre Libre,* Paris; 1921

Astruc, Gabriel; *Le Pavillon des Fantômes;* Paris; Grasset; 1929

Auriol, G.; *Les Rondes du Valet de Carreau;* Paris; Ernest Flammarion; 1887

Auriol, G.; *En revenant de Pontoise;* Paris; Ernest Flammarion; 1894

Auriol, Bernard, Veber, et al; *X . . . roman impromptu;* Paris; Ernest Flammarion; 1895

Auriol, G.; *Le premier livre des cachets, marques et monogrammes;* Paris; Librairie Centrale des Beaux-Arts; 1901

Auriol, G.; *Papiers Décorés;* Paris; Verneau and Chachoin; 1902

Auriol, G.; *Le second livre des cachets, marques et monogrammes;* Paris; H. Floury; 1908

Auriol, G.; *La Geste Héroïque;* Paris; Librairie Larousse; 1915

Auriol, G.; *Le troisième livre des cachets, marques et monogrammes;* Paris; H. Floury; 1924

Auriol, G.; *Steinlen et la vie;* Paris; E. Rey; 1930

Beraldi, H.; *Les Graveurs du XIX siècle;* 12 vol.; Paris; 1885-92

Catalogue Général des Editions; Paris; Enoch et Cie.; 1900

Cate, P. D., Hitchings, S. H.; *The Color Revolution, Color Lithography in France 1890-1900;* Peregrine-Smith, Inc.; Salt Lake City; 1978

Cerf, I.; *L'Art et le Livre;* Brussells; J. E. Goossens; 1911

Fields, A.; *Henri Rivière;* Salt Lake City; Gibbs M. Smith, Inc.; 1983

Fonderies Deberny et Peignot; *Album d'Alphabets;* Paris; G. de Malderbe et cie; 1924

Jullian, P.; *Montmartre;* Oxford; Phaidon Press Ltd.; 1977

Karsham, D. H., Stein, D.M.; *L'Estampe Originale, à Catalogue Raisonée;* New York, 1970

Madsen, S. Tschudi; *Art Nouveau;* New York; McGraw-Hill; 1967

Maillart, L.; *Menus et Programmes;* Paris; 1898

Marty, André; *l'Imprimarie et les Procédés de gravure au XX^{ème} siècle;* Paris; 1906

Marx, Roger; *La décoration et l'art industriel à l'exposition universelle de 1889;* Paris; 1890

Mellerio, André; *La Lithographie Originale en Couleurs;* Paris; 1898

Morin, Louis; *French Illustrators;* Scribners; New York; 1893

Nocq, H.; *Tendances Nouvelles. Enquête sur l'évolution des industries d'art;* Paris; 1896

Rivière, Henri; *Les Trente-Six Vues de la Tour Eiffel;* Paris; E. Verneau; 1902

Roger-Marx, C.; *La gravure originale au XIX^{ème} siècle;* Paris; Editions Aimley Somogy; 1962

Salis, R.; *Contes du Chat Noir—L'Hiver;* Paris; E. Dentu; 1889

Salis, R.; *Contes du Chat Noir—Le Printemps;* Paris; E. Dentu; 1891

Söderberg, R.; *French Book Illustration 1880-1905;* Stockholm; Almquist and Wiksell; 1977

Thibaudeau, F.; *La Lettre d'Imprimerie;* Paris; Au Bureau de l'Edition; 1921; 2 vol.

Thibaudeau, F.; *Manuel Français de Typographie Moderne;* Paris; Au Bureau de l'Edition; 1924

Tinchant, Albert; *Sérénités;* Paris; 1885

Uzanne, O.; *L'art dans la décoration extérieure des livres;* Paris; L. H. May; 1898

Verneuil, M. P., Auriol, G., et Mucha, A.; *Combinaisons Ornementales;* Paris; Librairie Centrale des Beaux-Arts; 1901

Weisberg, G. P., Cate, P. D., et al; *Japonisme, Japanese Influence on French Art 1854-1910;* Cleveland Museum of Art, Rutgers University Art Gallery, Walters Art Gallery; London; 1975

Wichman, S.; *Japonisme: The Japanese Influence on Western Art in the 19th and 20th Centuries;* New York; Harmony Books; 1981

Exhibition Catalogs

Baas, J., Field, R.; *The Artistic Revival of the Woodcut in France 1850-1900;* The University of Michigan Museum of Art; 1983

Catalogue de la Collection du Chat Noir; Hotel Drouot; May 1898

Catalogue de la Collection du Chat Noir; Hotel Drouot; March 1904

Centenaire de la lithographie; Catalogue Officiel de l'Exposition; Paris; 1895

Garvey, E., Hofer, P., and Wick, P.; *The Artist and the Book 1860-1960 in Western Europe and the United States;* Boston; Museum of Fine Arts; 1961

Japonismus und Art Nouveau; exposition, Hamburg Museum of Art; 1981

Société à Peintres-Graveurs; Galerie Durand-Ruel; Paris; April 1893

Société à Peintres-Graveurs; Galerie Durand-Ruel; Paris; April 1897

Société Nationale des Beaux-Arts; Exposition de 1895; Paris; Champ de Mars; 1895

Books by George Auriol

1887 *Les Rondes du Valet de Carreau;* Paris, Flammarion.

1891 Divan Japonais: *Pourvu qu'on rigole;* Revue en un acte et 3 tableaux de G. Auriol et N. Lebeau. Musique de M.J. Desmarquoy Paris, Blot impr.

1893 *Histoire de Rire, Flammarion*

1894 *En revenant de Pontoise, Flammarion*

1895 *X, roman impromptu* (with Courteline, P. Veber, T. Bernard, J. Renard), Flammarion

 " *Contez-nous ça, Flammarion*

 " *J'ai tué ma bonne, Flammarion*

1896 *Hanneton vole, Flammarion*

 " *Ma chemise brûle, Flammarion*

1897 *La chapeau sur l'oreille, Flammarion*

1899 *A la façon de Barbari, Flammarion*

1900 *La charrue avant les boeufs, Flammarion*

1905 *L'Hôtellerie du temps perdu, Flammarion*

1908 *Soixante à l'heure, Flammarion*

1910 *Les pieds dans les poches, Flammarion*

1911 *Sur le pouce, Flammarion*

1913 *Le tour du cadran, Flammarion*

1914 *La lucarne;* Paris, Fasquelle

1915 *La Geste héroïque des petits soldats de bois et de plomb;* Paris, Larousse. Ill. par A. Hellé.

1920 *Les Aventures du Capitaine Longoreille, lapin breton;* Paris, Berger-Levrault. Ill. par H. Avelot.

1930 *Steinlen et la Rue;* Paris, E. Rey.

Songs by George Auriol

-*Chanson Chinoise*

-*Quand les lilas refleuriront*

-*Jean Loriot*

-*Le Roi et la Reine*

-*Rondes et Chansons d'Avril*

-*Sur le Pont d'Avignon*

-*Le Marché d'esclaves, du film Divine*

INDEX

A

A.B.C. magazine, 115,117,118
A la façon de Barbari, 77
Album des Peintres-Graveurs, 72, 73
Alexandre, Arsène, 79, 84, 87
Allais, Alphonse, 21, 51, 55, 59, 60, 62, 98
Art et Décoration, 77, 79, 87, 89, 106
Art Nouveau, 66, 68, 69, 72, 79, 81, 87, 89, 91, 95, 106
Astruc, G., 94
Auriol, George
 book/cover design, 52, 60, 62, 64, 66, 69, 72, 73, 74, 75, 77, 84, 86, 87, 106, 110, 112, 113,
 Chat Noir programs, 52, 69
 Christmas cards, 77, 100, 102, 112, 117, 118
 critic, book reviewer, 115, 117
 editor, 23, 28, 30, 51, 59, 60
 59, rue Lepic, 97
 44, rue des Abbesses, 60, 77, 97
 lithography, 52, 55, 62, 65, 66, 69, 72, 73, 76, 79, 86, 87,
 menus, programs, posters, 62, 64, 72, 75, 84, 112
 military service, 28, 56, 71
 monograms, cachets, ex libris, 52, 55, 66, 77, 84, 94, 109, 112, 113
 music sheet covers, 69, 71, 76, 86, 106, 109, 110, 113
 ornamental design, 29, 52, 62, 71, 74, 76, 77, 84, 86, 87, 89, 91, 92, 106, 110, 112
 17, rue Racine, 28
 teaching, 114, 115, 117
 typography, 29, 52, 65, 84, 91, 93, 94
 woodcuts, 30, 55, 65
 writing, 30, 52, 59, 62, 71, 72, 75, 77, 106, 116
Auriol, Jean George, 100, 102, 107, 114, 115, 116, 117, 118, 119
Auriol, labeur, 91, 112
Auriol, Madam (Jeanne Docquois), 74, 75, 77, 98, 100, 117, 118

B

Barbizon school, 22
Batcheff, Pierre, 116
Batcheff, Sonia, 116
Beauvais, 15, 16, 17, 18, 19
Beltrand, J., 112
Bernard, Tristan, 71
Bernhardt, Sarah, 68
Bibliothèque Nationale, 118
Bing, Sigfried, 29, 68
Bismarck, 16, 17
Bloy, 21
Blvd. Rochechouart, 22
Bois frissonnants, 62
Boucher, E., 59
Boulogne-sur-Mer, 74, 77
Bouyer, R., 72, 87
Bracquemond, F., 29
Braque, G., 107
Brittany, 29, 74, 75
Brussells, 73. 74
Bucolique, 76
Buhot, F., 61
Burty, P., 29, 94

C

Cadbury, 94
Café de Tambourin, 29
Captain Cap, 60

Caran d'Ache, 21
Centenaire de la Lithographie, 72
Cezanne, P., 22
Cherét, J., 61, 74, 106
Chansons Atelier, 87
Chansons d'Hiver, 72
Chansons Naîves, 72
Chatellerault, 22
Chat Noir cabaret, 19, 21, 22, 23, 25, 26, 28, 29, 51, 52, 56, 59, 65, 74, 77, 97, 114, 116
Chat Noir journal, 19, 21, 23, 29, 59, 60, 62, 118
Commune, 17, 22
Contes du Chat Noir (l'Hiver) (Printemps), 52
Contes pour les bibliophiles, 72
Contes-nous ça, 71
Coutreline, G., 71
Cros, C., 21
Cross, H-E, 22
Cubism, 106

D
Dada, 107
Dali, S., 107
d'A Rebours, 91
de Chavannes, P., 74
de Feure, G., 68, 84
Degas, E., 22, 29
Delmet, P., 55, 87
de Swiy, 21
Docquois, G. 74, 75, 102
Docquois, Jeanne Augustine Margarite (Madam Auriol), 74, 75, 77, 98, 100, 117, 118
Donnay, M., 61, 118
Duchamp, M., 107
Durand-Ruel, 61, 72, 74

E
Ecole des Beaux Arts, 22
Ecole Superieure Estienne, 114, 117

Enoch, 69, 71, 74, 76, 79, 84, 86, 89, 94, 95, 97, 99, 106, 107, 109, 110, 113, 116
En revenant de Pontoise, 66
Expressionism, 106

F
Fau, F., 21, 52, 55
Fauves, 106
Firmin-Didot, '83
Flammarion, 61, 66, 71, 72, 74, 77, 83, 84, 95, 97, 106
fleur-de-lys, 54
Floury, H., 94
Fragerolle, G., 21, 55, 71, 74
Francaise legere, 91, 112
France, A., 94
Frank, N., 117
Freniet, 23

G
Galle, E., 66
Gallot, C., 59
Gandara, La, 21
Gardenia, le, 55
Gil Blas, 71
Gillot, F., 28, 83
Gismonde, 68
Gonce, L., 29
Goudeau, E., 21, 22, 23
Grand Dictionnaire Universel du XX^e Siècle, 86
Grammaire Lexicologique, 86
Grasset, E., 21, 22, 23, 28, 29, 66, 69, 91, 106, 112
Guérard, H., 61

H
Hannaton Vole, 72
Heidbrink, 84
Histoire de Rire, 61
Hokusai, 29
Huyot, Jean-George (father), 15, 16, 17, 18, 19, 62, 66

Huyot, Jean-George (George Auriol), 15, 16, 17, 18, 19
Huyot, Madam (Maillard), 15, 17, 19, 62, 77, 99, 115
Huyot, Maurice, 17, 18, 62, 66, 99, 115
Huysmans, 91

I
Ibels, H-G, 106
Institut, le, 22

J
Japonisme, 29, 52, 54, 61, 68
Jeanniot, 61
Jouard, H., 60, 94
Jouy, J., 21, 51, 55, 79

L
La Belle d'Aôut, 73
La Charrue avant les boeufs, 84
La Geste Heroique des petits soldats de bois et de plomb, 106
La Latern Japonaise, 52
La Lettre d'Imprimerie, 112
La Marche à l'Etoile, 76
La Revue de Cinéma, 116, 117
L'Art dans la Décoration Exterieure des Livres, 77
Larousse Commercial Illustre, 116
Larousse, P., 86
Latin Quarter, 28
Laurens, H., 83, 94
La Vie Drôle, 60
Le Art et l'Idee, 66
Le Art Japonaise, 29
Lebeau, 21
Le Beau Pays de Bretagne, 87
Le Chapeau sur l'Orielle, 72
Lecomte, G., 114, 119
Legay, M., 52
Leger, F., 107
Le Japon Artistique, 29
Le Musee d'Art, 86
L'Enfant Prodigue, 71

Le Pere, A., 112
Les Aventures du Capitaine Longoreille, 106
Les farces de Mijoulet, 65
les Modes de Paris, 76
Les Rondes du Valet de Carreau, 52
Les Sports Modernes Illustrés, 86
L'Estampe et l'Affiche, 76
L'Estampe Originale, 62, 65
Le Thyrse, 72
Le Vol à Paris, 52
L'Hotellerie du Temps perdu, 95
Librairie Centrale des Beaux Arts, 89
Librairie Larousse, 64, 69, 75, 79, 84, 86, 94, 95, 97, 99, 106, 107, 109, 110, 112, 113, 116
L'Image, 72
l'Imprimerie et les Procêdés de gravure au XXe siècle, 92
L'Orgie latine, 91
Loriot, J., 19
Lorrain, C., 21
Luce, M., 22
Lunel, 21
Lyon, 19

M
Ma Chemise Brule, 75
Majorelle, L., 66
Maillard, Claire Marie Josephine (Madam Huyot), 15, 17, 19, 62,
Maillart, L., 77, 84
Mallarme, S., 94
Marin, A., 73
Marpon et Flammarion, 19, 28
Marty, A., 92, 94
Marx, R., 62, 94
Mellerio, A., 76
Metz, 16
Monet, C., 29
Montmartre, 19, 21, 22, 23, 25, 28, 59, 60, 77, 84, 97
Moreau, G., 86, 95
Morin, L., 60

N

Nancy, 66
Nantua, 18, 19
Napoleon III, 16

O

Ollendorf, 84, 97

P

Paris Illustre, 28
Peignot, C., 113, 119
Peignot foundry, 69, 91, 94, 95, 99, 112
Peignot, George, 89, 91, 92, 94, 112, 113
Peignot, Gustave, 91
Picasso, P., 107
Pidoll, 112
Pille, H., 21, 23, 52
Pissarro, C., 22
Plon, 83
Ponchon, 21

Q

Quantin, 83

R

Raffaelli, J-F, 22
Renard, J., 71, 76
Renault foundry, 92, 94
Renoir, A., 22
Revue Encyclopedique, 62, 64, 86, 89
Rivière, H., 21, 23, 25, 26, 29, 51, 52,
 55, 61, 62, 64, 65, 66, 71, 72, 74,
 75, 76, 79, 86, 87, 94, 95, 98, 112,
 119
Robida, A., 52, 72, 84
Robur, 91, 112
Robur allongé, 112
Rollinat, 21
Rops, F., 84, 91
rue Victor Massé, 52

S

Sacré Coeur, 22
Salis, R., 21, 22, 25, 28, 52, 59, 60, 98

Salon de Champs de Mars, 66
Sarrazin, J., 65, 72
Satie E., 21
Schéhérazade, 79
Seven Week's War, 16
Shadow Theater, 52, 65, 71, 76, 86
Signac, P., 22
Société à Peintres-Graveurs, 61, 72
Société Nationale des Beaux-Arts, 72
Somm, H., 21, 52, 55, 94
Soulier, G., 89
Steinlen, T-A, 21, 52, 55, 74, 94, 112,
 116
Steinlen et la vie, 116
Studio, 107
Sudan, 16
Surrealism, 107

T

Tableaux Intuitifs, 95
Theâtre du Chat Noir, 55
Theâtre Libre, 62
The 36 Views of the Eiffel Tower, 87
Thibaudeau, F., 112, 114
Tinchant, A., 21, 28
Tissot, J., 29
Toulouse-Lautrec, H. de, 61, 94, 106

U

Uzanne, O., 66, 72, 76, 77, 83

V

Vallotton, F., 84
Van Gogh, V., 22, 29
Veber, P., 71
Verlaine, P., 94
Verneau, E., 62, 65, 75, 76, 84, 87, 94,
 98
Verneiul, M., 68, 89
Vierge, D., 84
Villièrs-Cottêrets, 19, 21, 66, 99, 115
Vollard, A., 72, 73, 74, 84

W
Whistler, J., 29, 61
Willette, A., 21, 22, 72, 94
World War I, 106, 107

X
Xau, F., 59
X, 71

Z
Zola, E., 22, 29
Zorn, A., 61